Nexus

Vol

E

t

Nexus

Theory and Practice in Contemporary Women's
Photography

Series Editor Marsha Meskimmon

Volume 1

Engendering the City:
Women Artists
and Urban Space

Marsha Meskimmon

Scarlet Press

Published by Scarlet Press
5 Montague Road, London E8 2HN

British Library Cataloguing-in-Publication Data
A catalogue record for this book is available from
the British Library

ISBN 1 85727 098 3 pb

Designed and produced for Scarlet Press by
Chase Production Services
Typeset from the author's disk by Stanford DTP
Colour printing by The Witney Press
Printed in the EC by J.W. Arrowsmith Ltd, Bristol, England

Contents

Illustrations

All works appear courtesy of the artists.

Michelle Henning, stills from *Tarfeather*, 1996

Debbie Humphry, 'Women Taking Testosterone' from *Gender Crossings*, 1995

Debbie Humphry, 'Transsexual with Mother and Son' from *Gender Crossings*, 1994

Karen Ingham, ' Boy with Toy Gun' from *Lost*, 1996

Karen Ingham, 'Child's Reins in Shopping Mall' from *Lost*, 1996

Bjanka Kadic, 'The Position of the Stranger' from *The Position of the Stranger*, 1996

Bjanka Kadic, 'Disjunction in Time' from *The Position of the Stranger*, 1996

Rosy Martin, *Pathways and Traces: Engendering a Sense of the City, part 2*, 1996

Rosy Martin, *Pathways and Traces: Engendering a Sense of the City, part 5*, 1996

Alexandra McGlynn, 'Mercury Lamp' from *Night Lights*, 1996

Alexandra McGlynn, 'Low Pressure Sodium Lamp' from *Night Lights*, 1996

Esther Sayers, *Perpetual Transition*, 1996

Esther Sayers, *Perpetual Transition* (detail), 1996

Magda Segal, 'Opsherin' from *The Lives of the Lubavitch Hassids*, 1996

Magda Segal, 'Barmitzvah' from *The Lives of the Lubavitch Hassids*, 1996

Emmanuelle Waeckerle, *Roadwork* (video still), 1996

Emmanuelle Waeckerle, *Roadwork* (detail, sign), 1996

Elizabeth Williams, 'Desert' from *Inscriptions*, 1996

Elizabeth Williams, 'Borderland' from *Inscriptions*, 1996

NEXUS:
Theory and Practice in Contemporary Women's Photography

Engendering the City is the first volume in the *Nexus* series and develops ideas from exhibitions held at Staffordshire University in September 1996. The works discussed in this volume are taken from the *City Limits* show curated by *Iris: The Women's Photography Project* to coincide with the international conference (*City Limits*) which concerned the wider cultural implications of urban space.

The exhibition was opened with a performance piece and contained work by ten contemporary women photographers who sought to engage with women's responses to the city as an actual, physical location and as a central organising metaphor for social interaction and communication. Most of the works discussed in this volume were produced in response to a call for submissions for the show and had not been seen before. In a few cases, the works shown in Stoke-on-Trent were parts of larger, on-going projects which were adapted specifically for the *City Limits* exhibition. The types of work in the show varied from 'new documentary' to interactive multi-media and installation. Despite this striking diversity in practice, particular themes appeared in the work time and again. The significance of gendered boundaries in urban environments, the sense of local, community links, the concept of the embodied spectator or 'pedestrian', the reappropriation of powerful or empowering places and the impossibility of reconstructing the universal, Utopian city of modernism were consistent as motifs in this varied body of work.

This volume explores these motifs both as they are developed through particular forms of practice in the works and as they relate to a whole history of feminist theory concerning women's renegotiation of space. Theory and practice are combined critically to encourage new understandings of the crucial significance of women's 'locatedness'; physical and social 'placements' are key underpinnings to the social practices which construct gender difference in our society and, as such, require an engaged response by anyone hoping to rethink traditional gender roles. This volume acts simultaneously as a retrospective exhibition catalogue and as an introduction to a series which will continue to examine the

relationships between theory and practice in the work of contemporary women photographers. *Nexus* explores the way ideas are transformed into visual praxis.

The history of women in photography is long and complex. Since its inception, photography has been a medium more open to the participation of women as producers than have traditional forms of fine art such as painting and sculpture. Arguably, however, this is not because of any more egalitarian approach to the medium, but because photography itself has an uncertain status as a form of 'art' and ill-defined rules of training and access. There were many early arguments to suggest that its mechanical or technological nature made it more appropriate to science than art or that it would, in fact, destroy the aura surrounding the work of art through mass reproduction. Its popular and 'amateur' status continues to make it a medium wrought with contradictions as an art form and a certain ambivalence can still be discerned in the very different ways people respond to, for example, mass media photography, personal 'snapshots' and photographs in the art gallery. But precisely these contradictions and uncertainties made it available to women from a very early stage and enabled female practitioners such as Julia Margaret Cameron or Florence Henri to become well known and respected in the late nineteenth and early twentieth centuries respectively when women's professional artistic practice was more generally marginalised.

Furthermore, female practitioners are well represented and well known in very diverse areas of photographic practice. Women have produced successful documentary work, fashion and advertisement photographs, photomontage, portrait work, experimental art photography, installation/video, phototherapy and many alternative forms of feminist political work. This wide base of female participation gives contemporary practitioners a strong history upon which to draw and a powerful foothold in the medium. Additionally, women's historical links to photography were not only through practice. Women have also been engaged in theoretical debates about photography. Practitioners and theorists have written influential texts on the history and theory of photography as well as the practice of women in the field. Again, photography's accessibility as a medium made it more available to women critics and theorists than the more traditional areas of fine art. Women could engage in the debates and challenge the parameters of this less stable form of practice. Because of this, women have helped to shape and define

the role of photography through their written as much as through their visual work.

Contradictorily, though, it is as subject-matter that women have their most definitive links with photography. From the experimental photographs of male practitioners such as Man Ray to the ubiquitous 'pin-up', the body of 'woman' is the mainstay of photographic imagery. It is precisely this interconnection between women as producers/theorists and as objects of photography which makes women's contemporary practice a fascinating engagement with the politics of representation. In a society such as ours which is hyper-saturated with 'images of women', women making images are in a unique position to question the significance of representation to issues of gender identity and cultural politics. Their presence and practice disrupts the traditional division between male artist and female model and challenges conventional modes of spectatorship.

Despite women's history as photographers and their strong presence in contemporary practice, it is significant that they are still widely under-represented in mainstream exhibitions, galleries and publications on the subject. Their history remains relatively hidden and their contemporary interventions eclipsed by the work of their male counterparts. This series aims to redress the balance by focusing attention on the particular issues raised by women's practice. The series will tackle a variety of areas, such as women in documentary photography, women's reconceptions of the maternal and the sexual body as well as women's responses to time and space, history and memory. The list is far from exhaustive as women's practice is rich and diverse. However, the themes tackled in the series begin the process of negotiation and exploration demanded by looking at the work. It is imperative that the masculine histories of photography be re-written in light of women's practice.

Nexus is concerned with the crucial interrelationship between theory and practice in women's photography which makes it such a rich vein of material to uncover. Thus, the volumes establish a number of different modes of engagement with women's photography rather than attempting to fix, artificially, a single, exclusive meaning to it. The volumes open up a dialogue between theory and practice without privileging either mode; they are intended to stimulate lively debate through various forms of interrogation. The interdisciplinarity of the series is part of this strategy. The authors are all involved with aspects of critical theory in their own work, but come to this photographic material from different disciplines and with different interests. Some approach the works as

ix

historians of art or photography, while others come from philosophy, film or literature backgrounds. Because of this, each author has a unique viewpoint to contribute to the series and there is no dominant, specialist mode of enquiry. The photographs discussed in this series and the themes of the volumes are not meant to exclude non-specialists but to bring this material to new audiences who, perhaps, have not had the opportunity to see this work before.

The same is true of the archival source of these photographs, *Iris: The Women's Photography Project* at Staffordshire University. As the only resource in Britain which exclusively devotes itself to the collection and promotion of contemporary women photographers' work, *Iris* is uniquely situated as a partner in these publications. Since its inception in 1994 in conjunction with the national programme *Signal: Festival of Women Photographers*, *Iris* has brought the work of its membership to light through exhibitions and conferences as well as an internet site and burgeoning plans for digital distribution. With continued research and development, the project seeks to make this work accessible and available to the widest possible audience. *Nexus* is part of this initiative to document the exceptional role of women in photography and bring this to increased public attention. The series draws its photographic material from the *Iris* collection and their archival documentation is the principal source of information about the photographers discussed in the individual volumes. Research on alternative areas of artistic practice and history can only be begun with the help of such resources as *Iris* which run counter to the dominant, institutional modes of collection which are changing very slowly in response to new demands from their users. *Nexus* demonstrates a fruitful collaboration between theory and practice and shows what a rich source of material exists in this pioneering project.

The publisher of this series, Scarlet Press, is similarly concerned with the recovery of women's histories and is itself an example of a feminist intervention into mainstream institutional practices which exclude women. Founded in 1989, Scarlet Press has sought to publish a wide range of books on all aspects of women's lived experience. The books are intended to appeal to both academic and general readerships, thus breaking boundaries between audiences and encouraging more stimulating arguments and debates to take place between everyone interested in the cultural history of women. This series continues Scarlet's feminist intellectual traditions and encourages its expansion into publications on the visual arts.

It is important to mention finally the support given to *Nexus: Theory and Practice in Contemporary Women's Photography* by Staffordshire University. In recognition of the value of the interdisciplinary collaboration of this series and the pioneering use of the resource, the Staffordshire University Research Initiative (through the School of Arts and the School of Design and Ceramics) granted the series the initial funding necessary for its production. The Arts Council further contributed to the costs of the production of high-quality illustrated volumes. It is encouraging to see the involvement of such large institutions in a project such as this and their foresight will be rewarded.

Marsha Meskimmon, Series Editor

1 Engendering the City: Women Artists and Urban Space

Engendering space

Approaching the topic of women artists and the city necessitates asking fundamental questions about the relationship between gender, space and representation. The theories and practices explored in this volume make connections between representational strategies, feminist conceptions of subjectivity and formulations of the urban. Underlying all of these positions are particular ideas about space, namely that space is neither empty nor neutral. Space exists as it is invested with meaning by and through the objects which interact within it; space is engendered by human subjects. To 'engender' means both to produce/create and to reproduce sexually. It is at once an overarching social word for production and a sexed term. In this way, it is the ideal signifier of making spaces meaningful through social structures in which gender difference is always and already present. Consequently, space is neither empty of cultural forms, like some sort of pre-existent *tabula rasa,* nor is it a gender-neutral stage on which people act. Space is a central organising metaphor for all forms of social discourse and gains its meaning through the placement of objects (especially people) in relation to each other. As Elizabeth Grosz argues:

> the ways in which space is perceived and represented depend on the kinds of objects positioned 'within' it, and more particularly, the kinds of relation the subject has to those objects ... A space empty of objects has no representable or perceivable features ... It is our positioning within space, both as the point of perspectival access to space, and also as an object for others in space, that gives the subject a coherent identity and an ability to manipulate things, including its own body parts, in space.[1]

Space is therefore doubly constructed in relation to subjects; people's orientation in space both reflects their identities and forms them. Where you are placed, literally and figuratively, tells you who you are. It is determined by and determines your identity as a social being with all the attendant variations of, for example, class, race,

age and, of course, gender. Spaces are given meaning through our bodily encounters with the multiple differences which situate us as individuals in larger communities. To discuss the issues raised by women's representations of urban space requires us to begin to think about space as a meaningful, social idea. It is the concept of 'lived', meaningful space which is considered throughout this volume. Women photographers encountering the city invest their work with significance through bodies, objects and experiences. What is fascinating about taking their work as a starting point for thinking about women and space is what Gillian Rose has called the 'paradoxical space' of feminist geography.[2] The women taken as the focus of this volume occupy both the centre and the margin; they are both inside and outside. As artists making work about the spaces of the city they are the producers, subjects in control. As women within the spatial limits of the city, they are marginal.

Understanding space as engendered is crucial also to the feminist project of rethinking gender difference. It runs counter to the dominant traditions of examining space, derived from physics and geography, which describe space as stable and neutral. In these accounts, space pre-exists social interaction and can be quantified in objective, rational accounts. The knowing subject is conceived outside space and as the master of its vagaries. And *master* it is; as Rose has argued so effectively in *Feminism and Geography: The Limits of Geographical Knowledge*, the science of space maintains masculine paradigms which render women invisible both as users of space and as producers of geographical science. She states:

> It seems to me that women's exclusion is not only a question of the themes of research, nor even of the new concepts with which feminists work to organize those themes, but rather a question related to the very nature of hegemonic geographical knowledge itself. I suspect that there is something in the very claim to knowing thought in geography which tends to exclude women as producers of knowledge, as well as what are seen as women's issues as objects of knowledge.[3]

Women's relationship to space is a critical factor in the structures which underpin gender difference and operates both literally and figuratively (as indicated above) so as to describe and prescribe simultaneously social configurations.

For example, it is fascinating in itself to consider the access of women to real spaces. A number of cross-cultural surveys of this

2

theme have been undertaken and, though details and spatial arrangements differ, it is clear that women and men have very different access to social space and this differential access defines their roles. This is also true of western society past and present. The struggles of women at the end of the last century for access to educational institutions and the hallowed realms of the political, medical and judicial systems are a case in point. It was imperative to be present in these public spaces in order to have the voice to redefine the status quo. It was not adequate to remain physically within the domestic environment and be represented by others. But this access to space was not just a matter of physical presence; it was also an act of empowerment, a seizure of a metaphorical site as much as an occupation of a particular spatial location.

Crucially, the most striking characterisation of this dual sense of space for women is encapsulated in the title of Virginia Woolf's well-known work *A Room of One's Own*.[4] In describing the conditions necessary for women to produce fiction, Woolf coined the phrase to stand for both physical space and creative/intellectual freedom through control of space and, by extension, one's place in the world. A room in which to work as well as the financial independence to use it were the first steps towards women's professional practice as writers. As long as women were located solely as domestic workers, they would have neither the space nor the freedom to produce literature. But this room was also the social and psychic location of women as independent individuals for Woolf; it acted as an organising metaphor to sum up the newly desired 'situation' of women as fully-formed social actors.

It is no coincidence that Woolf used a spatial metaphor to conceptualise the fully independent social subject. Spatial metaphors are powerful evocations of people's roles and social identities. For example, to be 'out of place' in a situation means more than just to have stumbled into the wrong room. It suggests that social boundaries have been transgressed. The same is true of concepts such as being in 'unfamiliar territory' or just not 'at home'. These boundaries are often highly political, as in the case of the phrase 'beyond the pale' which, during pre-partition British rule in Ireland, limited acceptable social space to the Anglo-Irish centre around Dublin and banished all other areas to the disreputable margins.

The very concepts of centre and margin (or periphery) are critical to both traditional discourses of power and those which attempt to subvert them. The discourses of colonialism, for example, defined a particular place as the centre or norm against which all else was

3

defined as marginal or other. This process extended beyond simple geographical location and maintained such culturally exclusive centre/periphery tropes as 'civilised/primitive' or, more crudely, 'white/black'. This reinstates the significance of the slippage between the literal and the metaphorical conceptions of space. The powerful modes of thinking about difference which are enshrined in centre/periphery models of self and other have underpinned western logic systems for centuries and are also the basis for the paradigms of gender difference which define 'woman' as the negative, marginal other to the centrality of 'man'.

A number of challenges to hegemonic western thinking have been waged over the last quarter of this century from marginal groups who have begun to find a voice. Feminisms and post-colonial theories have most consistently countered the spatial logic of the centre/periphery divide and pointed out how critical the 'placement' of people on one or other side of physical and ideological boundaries is to determining their empowerment or lack of voice. The significance of borders has been one of the key political insights of these strategies. Spaces are not only full of objects in relation to one another, they are full of real and metaphorical boundaries which curtail interaction between 'different' objects. Social order is maintained through the policing of boundaries in all senses. We learn to 'know our place' and where its limits lie and if we do not, we suffer the consequences.

For women, these spatial conjunctions can be particularly restrictive. Shirley Ardener refers to 'ground rules and social maps' to explain the ways in which women come to know their place in society both literally and figuratively.[5] The 'safe' areas of home and local community tend to be fewer and more sharply defined for women than they are for men. Women are 'safe' in more limited spaces and more vulnerable in public areas. Rape and the threat of rape are the most definitive modes of border control for women in public spaces and common responses to the instances of rape make these ideological as well as physical threats.[6] For example, a woman raped in her own home by a stranger (a male who transgressed the threshold of her safe domestic interior uninvited) usually will receive sympathy in the courts and the popular press. This is clearly not the case for a woman out alone at night who can, unbelievably, still have to answer the charge that she 'asked for it'. The limits on rape in marriage and 'date rape' are even more obscure. These attitudes have nothing to do with the violation of women or the actual circumstances of most rapes (most are committed by people known

4

to the raped woman), but rather these concern definitions of women through their social placement in relation to men. A woman may only legitimately come into contact with specified men and in particular places or she 'asks for' punishment. The ambivalence inherent in these boundaries is one of desire and danger as women can attain power only through increasing access to space yet this space can pose very real threats. Thus, transgressing boundaries can be simultaneously frightening and liberating, necessary and dangerous.

All of these thoughts on the engendering of space are crucial to the work of women artists who consider the theme of the city. The spaces they describe are meaningful and multiple and derived from their bodily encounters with the city. Their work is placed on a transgressive borderline and almost every piece from the *City Limits* show contends with boundaries whether bodily or geographical. Community plays a leading role along with the local and the pedestrian as ways of rendering the specificity of spaces. It is in the renegotiation of the earliest visual paradigms for the city, the Utopian visions of the city of modernism, that provides the aesthetic framework through which these theoretical insights are developed.

Modernity, modernism and the city

Many of the aesthetic conventions associated with representations of the city are derived from European modernism. This is not surprising given both the significance of cities in the historical development of modernist art practices and the pivotal role of the city in discursive constructions of modernity and modernism during the end of the nineteenth and beginning of the twentieth centuries. The city was the location, *par excellence*, of modernism; the conditions of life and perception set up through the social and spatial relationships of the first modern cities in Europe determined the forms of visual works in the period. Cities were the places in which the social and economic frameworks necessary to modern art flourished. The urban environment was home to the exhibition spaces, dealers, bourgeois patrons and art press required by the avant-garde for its success. Moreover, the representation of the city itself was critical to modernist practice and the city became paradigmatic of a new mode of seeing. The speed of life, the spectacle, the commodification and alienation of the urban scene and the fragmentation of the spatial realms of the city all created ways of seeing, experiencing and representing space which challenged the traditions of art up to that time.

5

Modernist negotiations concerned urban space both as subject-matter and form. In terms of the urban scene as subject-matter, much of the criticism of early modernist art was to do with the inappropriate, low nature of these spaces. This will be taken up at greater length below, but it is instructive to remember here that the most traditionally accepted triumphs of modernism involved the use of space as a formal, compositional element. Hence, urban spaces were fundamentally ambivalent in the modernist project. As a key focus of the lionising of modernist art, the debates surrounding the work of the cubists frequently concentrated upon the challenges waged by this type of work to the tradition of rendering perspective in western painting. Ernst Gombrich wrote in his well-known text *The Story of Art*, of the cubists' work:

> He [the cubist painter] invited them [the critics] to share with him in this sophisticated game of building up the idea of a tangible solid object out of the few flat fragments on his canvas. We know that artists of all periods have tried to put forward their solution of the essential paradox of painting, which is that it represents depth on a surface. Cubism was an attempt not to gloss over this paradox but rather to exploit it for new effects.[7]

Such a reading of Cubism constructs for us the dominant critical model of modernism which relies on a strictly formal or visual analysis rather than engaging with the contradictory nature of modern art's themes, subject-matter and historical construction. It also presumes that new modes of seeing and representation were necessary in the new urban environment and that these were pioneered through experimental art practice. Conventionally, it links Impressionist and Post-Impressionist antecedents to such movements as Expressionism, Cubism and Futurism and then asserts their legacy to abstraction. Such 'formalism' tends towards a universal reading of modernism as a progressive narrative of experimental breakthroughs produced by a number of individual male genius figures.

The contradictions within the modernist project and, in particular, in the representations of the city in modernism are most commonly glossed over to form simplistic narratives of universal, Utopian modernist art and the male artists who produced it. The powerful links forged between the city, modernity, modernism and the viewpoint of the male artist are difficult to break, but they must be broken if we are to understand the interventions of women artists in

this arena. The first stage in deconstructing these mythic representations of the city is to explore the ambivalence and gender-bias of their most common tropes: the fragmented city, the dynamic city and the spectacular city. Each of these tropes of urban space was developed through a language of patriarchy and the norms of representation associated with them are neither gender-neutral nor universal, but masculine. Women artists coming to the theme of the city have actually used the inherent ambivalence and complexity of modernism (rather than merely evading its tropes) as a means to revisit powerful evocations of the urban in representation and give women a place within these. Hence it is necessary to explore the ambivalent city of modernism.

The fragmented city

As cities grew larger during the nineteenth century, the social interactions common to small communities waned in favour of patterns of urban interchange. In turn, spatial relationships altered. In place of the multi-stranded, informal relationships between community members in small towns, cities encouraged complex, single-stranded communications between people. This shift is significant; in a small community, people may be in various forms of social hierarchy, but they will know one another. Furthermore, they frequently will have more than one (that is, multi-stranded) form of interaction with other members of the community; the baker may also be the butcher's cousin and belong to the same clubs, and so forth. In large cities, these multi-stranded relationships tend to be broken down to a much greater extent. Your baker is more likely to be a local business person and not know you in any other way (that is, single-stranded). Such a situation formalises interaction between people and sets up a system in which it is possible to spend most of your time among strangers. All of this leads to the experience of alienation common to city-dwellers and to certain forms of spatial fragmentation typical of the experience of the city in modernism.

If a complex system of interpersonal communication and exchange is to work efficiently, space must be arranged to accommodate it. In big cities where single-stranded interaction is highlighted, concomitant forms of spatial differentiation are necessary. 'Specialist' areas such as shopping precincts, museum districts, factory/warehouse centres and neighbourhoods develop in large cities and serve to fragment spaces and social activities. For

7

instance, 'Fleet Street' was and 'Saville Row' is London's distinct areas for press and tailoring respectively. The activities and spaces have become synonymous in common parlance; to say 'Fleet Street' is to name the press. The disparate areas of big cities are connected through networks of transportation and communication which are controlled carefully so as to maintain 'proper' and manageable interchanges. There are correct places in which to meet certain people and outside those places there may be danger. For example, a middle-class woman may see a male builder on the street in broad daylight, but will not want to be with him in an alleyway at night. That is, in addition to the spaces of the city being divided by enterprise interests, they are also clearly divided by class, race and gender. Social distinctions between people in the city are reinforced by sharp spatial divisions. The physical barriers and social/ideological boundaries of the city are one of its principal features and the concept of public and private spheres speaks of the significance of gender in determining the placement of these barriers.

The fragmentation of the city into public and private spaces, the spaces of mass social interchange and those of the home and family, is pivotal to gender boundaries and their maintenance. Traditionally, of course, women were assigned to the spaces of domesticity, naturally assumed to be the guardians of the private sphere. While men ventured into the 'dangerous' areas of the public sphere to make a living, engage in politics or forms of popular entertainment, their wives, mothers and daughters remained within the safety of the home. Women experienced the excitement of the city at a distance: accompanied by men to a very limited set of public places or through the view from their own homes or other safe interiors.

However, this model is merely an ideal model about middle-class women. It exerted a hold during the early years of this century through its desirability more than its truth to women's experience. Besides the fact that working-class women had jobs outside the home which made them enter public spaces with more frequency than their middle-class sisters, women of all classes were beginning to have access to the public sphere in greater numbers during the modernist period than before. Again, even the divisions of space so critical to the modernist project were more complex than the standard versions permit; the spatial control meant to be exercised through these divisions was, in fact, self-contradictory. As Whitney Chadwick has argued, certain early modernist movements such as Impressionism actually pitted the stability of the domestic sphere

against the threat of the city in an attempt to respond to changing gender and class roles which were making these public/private divisions inconsequential.[8] Thus the discourse of public/private was very much intact as a concept if not as a lived experience at the beginning of the twentieth century and remained a powerful ideological weapon against women's emancipation well up to mid-century.

What is fascinating about the concept of public/private space for modernism is the way in which particular *public* spaces became quintessential locations of 'modernity'. Certain public spaces were the representational norm for artists from all over Europe from the middle of the nineteenth century to the middle of the twentieth. Arguably, it is not just the public nature of the spaces so commonly associated with modernism which marks them out, but their liminal, borderline, quality, their placement on the dangerous boundaries within public, urban spaces. Only at certain points could the city provide its maximal transgressive *frisson* and, at these points, modernist art flourished. But again, these are not neutral or universal spaces, they are transgressive because of the interaction between margin and centre for the male subject. These spaces all represent dangerous meetings between the social classes or, more significantly here, the sexes. The spaces most commonly described by male modernists were the city street (often at night), the café/theatre and the brothel. It is noteworthy that all of these places were exciting sexual spaces and, at least at some particular times of day, off-limits to most women lest they risk their 'respectability'. Furthermore, the liminal figure of the prostitute, the female figure who transgressed these boundaries of respectable sexual behaviour, became almost a cliché of the city as represented by male modernists.

The prostitute and the corresponding spaces of dangerous social interaction between diverse urban subjects represented the new risks of the city and also its thrill. Here the avant-garde could assert themselves as 'outsiders', the kind of marginal figures whose art was marketable to mainstream bourgeois collectors of the period.[9] Their transgressive role was highly significant to marketing themselves as *the* privileged spectators of the excitement of modern life. When Charles Baudelaire heralded Constantine Guys as 'the painter of modern life' and supported the challenging works of Edouard Manet, he marked a turning point which had already begun in practice; the links between the modernist artist, the situation of modernity and the liminal space of the city were in place.

9

Manet's work of 1863, *Olympia*, and the scandal which accompanied its exhibition is a case in point. *Olympia* represented a female nude reclining on a *chaise-longue*; as such, it was typical of the western tradition of reclining female nudes as mythological figures, bathers or courtesans. What was scandalous about Manet's work, however, was that the figure was not mythological but identifiable through a host of contemporary references as an urban, working-class, Parisian prostitute. The matter-of-fact painting style and the confrontational gaze of the Olympia figure took this work outside the bounds of appropriate fine art canons with respect to the female nude. This liminality transgressed the well-defined barriers of social space and interaction. The prostitute was the site at which different social classes and sometimes races met in simultaneous commercial and sexual union. The carefully constructed boundaries between people in the city here collapsed in a thrilling and dangerous intercourse. Here was located modernity and here was located the (male) modernist.

Such imagery was ubiquitous throughout modernist art practice in Europe. In France, the prostitute and the brothel continued as a major subjects in works such as Picasso's *Les Desmoiselles d'Avignon* (1907). In Britain during the same period, Walter Sickert's series of works on the Camden Town murders explored the distressing theme of murdered, working-class women defined in contemporary discourses as 'prostitutes' at the same time as it introduced modernist continental formal traditions into British art. The *Lustmord* (sex murder) theme became a powerful evocation of the dangers and the excitement of the city during the 1920s in Germany and again linked modernist artistic practices ranging from Expressionism to the *Neue Sachlichkeit* (New Objectivity) with the theme of the (murdered) prostitute.

Like the figure of the prostitute, the public spaces of the city, with their suggestions of threatening transgressions of gender boundaries and sexual barriers, continued to hold their primary position in modernist art practice throughout the first half of the twentieth century. Public squares coursing with all sorts of different people, city streets at night, cafés and nightlife were the stock in trade of artists associated with trends as diverse as Futurism, Vorticism, the New Objectivity and Surrealism. The experience of urban space as fragmented and dangerous was an overriding theme throughout modernism and the types of representational forms which emerged in the period forged links between marginality and art practice while reinforcing the control of the (male) artist over this wild, threatening

space. Yet it is clear that this trope was as much a fiction of the male subject faced with the emancipation of women as it was 'real'; underlying this aspect of modernist practice was the ambiguity of women's placement in this gendered urban space. Precisely the features of marginality, fragmentation and boundaries are questioned by the women artists discussed in this volume as they rework the modernist paradigms to find their own interpretation of the city. They look to ambivalence, fluidity and the partial subject denied by male modernists.

The dynamic city

The city of modernism was not only fragmented, it was fast. Speed and dynamism were all-encompassing features of the experience of space in the city. As early as 1902–3, the German social theorist Georg Simmel wrote of this phenomenon in an essay entitled 'The Metropolis and Mental Life'. Simmel asserted that the shift in dynamism from small towns to big cities fundamentally altered the perception of the subject:

> The psychological basis of the metropolitan type of individuality consists in the *intensification of nervous stimulation* which results from the swift and uninterrupted change of outer and inner stimuli. Man is a differentiating creature. His mind is stimulated by the difference between a momentary impression and the one which preceded it. Lasting impressions, impressions which differ only slightly from one another, impressions which take a regular and habitual course and show regular and habitual contrasts – all these use up, so to speak, less consciousness than do the rapid crowding of changing images, the sharp discontinuity in the grasp of a single glance, and the unexpectedness of onrushing impressions. These are the psychological conditions which the metropolis creates.[10]

That is, the sheer dynamism of the 'onrushing impressions' meant that people had to change the way in which they perceived sensory data lest they be completely overwhelmed. This very link between perception, representation and the dynamism of the city was made by a number of modernist artists.

Artists associated with Futurism in Italy most notably used the speed and motion of the city as the major theme in their work and

they stand here as an example of the issues at stake in such practice. 'Universal dynamism' was the term they coined to describe the new experience of the modern, technological city. In works such as Umberto Boccioni's *The Street Enters the House* (1911) or Gino Severini's *Dynamic Hieroglyphic of the Bal Tabarin* (1912) the archetypal spaces of the city discussed above (the public square/the street/the nightclub) are combined with the powerful forces of speed – experiences of space and time become the subject of the work. Later, futurists would produce fully abstract works which took the theme of space/time as the only subject. Such works would move from any direct reference to city spaces leaving only the indication of dynamism as in, for example, *Study for the Materiality of Lights Plus Speed* (1913) by Giacomo Balla.

Other abstract artists, such as the Russians involved with Rayism and Suprematism, two of the earliest forays into abstract art in Russia during the first decades of this century, would also make the conceptual leap from the dynamism of the modern, urban environment to its representational equivalent in forms of universalising abstract or non-objective art. For example, the artist Mikhail Larionov's manifesto introducing the abstract works of Rayism in 1913 opened thus: 'We declare the genius of our days to be: trousers, jackets, shows, tramways, buses, aeroplanes, railways, magnificent ships – what an enchantment – what a great epoch unrivalled in world history.'[11] In 1919, Kasimir Malevich would continue this association of abstraction with contemporary ideas of time and space in 'Non-Objective Art and Suprematism'.[12] Though abstraction seemed an ideal form to many avant-garde artists exploring these concepts, even artists who continued to adhere to some form of representational practice were strongly affected by the theme of the dynamic city. For example, Russian and German film-makers and photographers would experiment with techniques of montage in order to produce a formal, visual equivalent for the subject in modernity. Two films from the 1920s, made in Germany and Russia respectively, Walter Ruttmann's *Berlin, Symphony of a City* and Dziga Vertov's *Man with a Movie Camera,* both used these montage techniques to great effect to represent the city itself as the main character. In these films, fragments of the city's movement (human and mechanical) were montaged together to form a 'whole'; conventional narrative styles of film-making gave way to the dynamic equivalents for the experience of the city.

Women had an ambivalent relationship to the theme of the dynamic city as well. Mainly in contact with the least technological

sites in the city and moving through urban space principally as pedestrians, women had more limited access to the underlying change in perceptual experience which led to the experiments with space and motion. Furthermore, women were alienated from much of the scientific debate about space/time during the period which underpinned many modernist aesthetic developments. Women artists rarely worked in the most highly theoretical realms of abstract art and were explicitly eschewed by such masculinist movements as Futurism. Therefore, the dynamic city was, like the fragmented city, more paradigmatic of the male subject's relationship to urban space.

However, these formal, visual experiments developed the most striking aesthetic models for thinking about urban space at the time and still exert a powerful hold on artists who use the city as their theme. Although some of their underlying paradigms have been challenged during the latter half of this century, it is still pertinent to query the relationship between visual perception and the experience of the urban environment since contemporary representations of the city must contend with the aesthetic legacy left by modernist practice. It is not sufficient simply to dispense with modernist techniques; rather, these must be interrogated and then reinvented for different purposes. As described before, modernist practice was marked by ambivalence towards urban space; these spaces were seen to be both empowering and terrifying, they were the origin of modernism's utopian formalism and its dystopian view of the human condition. Hence, modernist techniques can be useful for women artists who wish to critique the city, but they also risk being seduced into the masculine viewpoint which so often underlies the formal innovation. As will be explored at greater length later in this volume, the use of multiple viewpoints, montage and an acknowledgement of the relationship between space and time are all still significant in contemporary women's interventions into urban imagery, but are mobilised towards different ends.

The spectacular city

A final pervasive feature of the city in modernist discourse and representation is the notion of the city as the site of spectacle. Like the other powerful tropes of urban space, the spectacular city is a gendered city. But here women, or more specifically *woman*, had a central role to play. Signifying 'women' and 'woman' is critical in this context as it indicates the difference between *women* as people who

13

actually lived in particular cultural conditions defined in and through their biology and social status and *woman* as a conceptual and symbolic category. 'Woman' was invoked discursively in a number of ways which actually contradicted the lived experience of women. 'Woman' is a relatively undifferentiated term applied more as an idea than as an accurate description of female subjects; it is produced ideologically in relation to 'Man' as his 'other'. This distinction between women as producers/consumers of the spectacular city and 'woman' as a symbol of the city and spectacle itself has important ramifications for representational strategies.

The city of modernism was thought to be increasingly the city of display. Advanced commodity capitalism enlarged the number of items available to the consumer and changes to the nature of shopping meant that these items were out on show for the self-serve shopper rather than behind the counter of the old-fashioned full service stores. Additionally, the spaces of the city actually altered during the period with architectural designs which permitted arcade building and huge shop windows facing city streets. Electric lighting meant that these windows were illuminated as 'stages' and the activity of 'window shopping' became a form of entertainment peculiar to the spectacular city and even the latest model for the production of cabaret forms.[13] Large-scale advertising increased with the rapid development of lithographic posters on billboards as well as new, neon signs.

The spectacle and display associated with modern urban culture was further extended to the phenomenon of the world fair or national exhibition which was so prominent during the period. Here the nation or the city itself was the display, with its products and achievements arranged as commodities in shop windows. The industrial wealth of the nation/city, the cultural life and even its colonial supremacy were measured and consumed as commodities. These aspects of spectacle were the object of fantasy and the displays tended toward sheer excess. For example, at the 1924 Wembley British Empire Exhibition kiosks displayed everything from raw materials and finished goods made in the empire to the indigenous peoples of the far corners of British imperial rule. Everything and everyone was now commodified.

The full implication of commodity capitalism on the status of women in the city is complex. On the one hand, the changes in display and consumption which accompanied advanced commodity capitalism meant that women became the primary targets of advertisements and the principal consumers in the modern city.

A majority of the household and fashion goods sold were bought by women. In this one sense, women's economic power increased during this period. More significantly, however, women were intimately associated with the spectacle of consumer culture through shopping, fashion, mass media and even shop window displays. They were participants in this commodity form as consumers but, moreover, they were linked through their very bodies to display, artifice and entertainment. Women became part of the spectacle of the city as they walked through the streets shopping, went to the cinema or, increasingly, out to work. 'Woman' was the ubiquitous spectacle in magazines, films or shop windows; as models and mannequins, the image of woman entered into the excessive display of the city. The increasing visibility of women/woman in the public sphere reinforced their role both as transgressors and as a spectacle in themselves and placed the 'woman question' on to the agenda. As Dorothy Rowe has argued so effectively about Berlin in the 1920s, the city itself came to be identified as a desirable and seductive woman.[14] 'Woman', as an exciting and dangerous other to man, epitomised the thrill of the spectacular city for the male subject and yet described another ambivalence in the modernist city for women.

The association of women with spectacle and display has significant ramifications for the gendering of looking itself. If the spectacular city is a desirable woman and 'woman' is the object of the look, then the subject doing the looking is masculine by definition (and usually a man, literally). That is, a binary system is in place to define subjects and objects in the urban sphere and the subject is defined as masculine/male, while the objects at which 'he' looks are defined as feminine/female. Thus, the empowered position of the viewer in the modernist city was masculine. And, although the masculine/feminine divide in looking is structural and not necessarily literally attached to biological sex, men and women living in the urban environment were subject to its vagaries. Those in control in the city controlled the spectacle and determined the power relations of viewing itself. The ubiquitous representation of woman in the city set up an unequal power relationship between men and women as subjects and objects of the look. Women might control viewing, but they were far less likely to do so both because of their social circumstances and the pre-existent structures of looking into which they were interpellated as subjects. It is with the inverse of spectacle, namely invisibility, that this becomes most clear.

The ultimate spectator is an invisible spectator, able to look at everything without being looked at. The privilege of invisibility, of

being relatively unnoticed, accompanies the control of space. That is, when you are in a familiar place in which you have status, you may display yourself, but you may also choose to remain 'invisible'. Only in places where you are not in control or, literally, 'out of place' are you perpetually rendered a spectacle whether you like it or not. To 'make a spectacle of oneself' is the corollary of being too visible in an unfamiliar space. People make spectacles of themselves by not fitting in, by standing out in an embarrassing way and by being objectified by the other, less 'visible' spectators.

Thus, women's link to spectacle in the modern city was a symptom of their actual lack of control of that new space. The male subject was empowered to look, while woman was to be looked at. This gendering of the look could both undermine women's new public status (that is, working women subject to perpetual staring and harassment as spectacular objects) or, more rarely, be used by women as an empowering strategy. However, women who chose to play with their role as spectacle were taking many risks and not many were successful. The self-conscious adoption of the role of the spectacle is fine when you have the option of 'invisibility' available to you; when you do not, it can lead to dangerous encounters. Significantly, this fictive invisibility has been identified as a crucial feature in cross-cultural studies of women and space. Wherever women seek power over spaces, they require the ability to opt out of being 'looked at' and the accompanying control of viewing as subjects rather than objects.[15] It is in this contradiction between invisibility and spectacle that contemporary women artists can find a space to challenge concepts of looking and representation. By confounding clear lines between the subjects and the objects of spectacular viewing, they are able to maintain a critical space on the border of these positions. This enables them to imply new strategies of seeing and knowing the city and the female subject in that space. Precisely these challenges to seeing, knowing and power are embodied by the reworking of that archetypal modernist subject, the *flâneur*. The ideal spectator described in modernist discourse was the *flâneur* (or stroller) and the key feature of the *flâneur* was his ability to view while remaining unnoticed.

The flâneur and the pedestrian

The centrality of the figure of the *flâneur* to modernist discourse is well documented. From Charles Baudelaire describing modern Paris

in the nineteenth century to Walter Benjamin linking Paris with Berlin in the 1920s, the *flâneur* has an impeccable pedigree as the model of the contemporary writer/artist of modernism.[16] It suffices here to review just a few features of this trope in order to understand how urban space interpellated a particular masculine subject. The *flâneur*, or 'the stroller', was the figure who moved through the city experiencing its full range of new perceptual phenomena. His ability to move freely through the disparate spaces of the city meant that he was the figure for whom the fragmented city was homogenised. Unlike old-fashioned types such as the *haute bourgeois* or the manual labourer, the *flâneur* was not limited to any particular region of public space. Rather, this new, quintessentially modern figure strolled along the boulevards and avenues at will, transcending the divisions of space in the city. In this way, the *flâneur*, as the archetypal modernist writer or artist, could form impressions of urban space which were whole or complete in that they encompassed all of the fragments simultaneously. The Utopian control of the city so typical in modernist practice has its origin in the special subject who can experience the total city.

The *flâneur* thus had an ideal relationship to both the fragmented city and the dynamic city. Those phenomena were simultaneously experienced and controlled by the modernist who used them as raw material from which to forge new artistic forms. Moreover, the *flâneur* as a type was also intimately tied to notions of spectacle. As suggested above, the *flâneur* embodied the characteristic of fictive invisibility so empowering in the city. The stroller never made a spectacle of himself; witness to all forms of display, his was the disembodied eye which saw without being seen. In order to move through all of the boundaries of the city, it is imperative never to stand out as an object. This privileged subject position was not wholly novel in the modern period, but derived from a western tradition which linked 'objective' seeing and knowing in a particular way.

Western epistemologies, or knowledge systems, have traditionally privileged sight as the most perfect and truthful sense and the one best suited to rational knowledge claims. Since the Enlightenment, when forms of rational, scientific knowledge became dominant over intuitive, sensual understanding, clarity of vision, literally and figuratively, has been paradigmatic for truthful knowing. In literal terms, the concept inspired forms of scientific experiment dominated by vision such as dissection, microscopic analysis and the classification of objects in the world through visible differences and similarities. Historical truth claims centred on verifiable 'facts' and

documents which could be seen; mimesis, or naturalistic likeness, was predominant in the aesthetic sphere. Figuratively, concepts such as 'seeing clearly' and being 'enlightened' indicated a growing acceptance that truth and rational knowledge could be obtained best through an objective 'sight'. In this way, both literal 'seeing' and the language of visual metaphor became imperatives in rationalist conventions for understanding space as well as other phenomena.

These paradigms of sight are intrinsic to two fundamental western concepts: the universality of knowledge and the rational (objective) subject. Universal claims rely upon the idea that there is one truth available if and when the scientist/philosopher/viewer can perfect his viewpoint. If the whole object or problem can be seen completely and with total objectivity, its truth will be revealed. The subject who can know in this way is the rational subject who must dispense with partiality in the quest for clarity of understanding. This is the idealised model upon which many scientific knowledge claims have been constructed; the objective scientist who experiments upon material to learn its secrets and yet remains outside the boundaries of the experiment himself. In art, this is the mimetic model of the objective viewer who renders what he sees with perfect naturalism through the rules of perspective and draughtsmanship. This rational subject sees while remaining invisible.

This knowledge ideal, based upon concepts which link seeing, knowing, power and rationality, has had a tremendous impact upon traditional conceptions of space of which the modernist city is but one example. As discussed earlier, geography as a scientific discipline was modelled precisely upon this ideal and has privileged its universal truth claims about the nature of space and place accordingly. Classical forms of geography begin with the idea of empty spaces which can be measured objectively and populated spaces which can be observed/analysed from outside. This leads to universal systems of understanding human interaction with space which are actually dependent upon the presumed pure objectivity of the observing geographer. The principal myth of this observing subject is that it is gender-neutral as well as classless and colourless but, as recent theoretical interventions have shown, the 'universal', transcendent subject of western knowledge hides the actual subjects of this empowering discourse who are white, male and middle-class.

Feminist theoretical interventions have formed one of the main challenges to these universal claims about the subject and the world s/he inhabits. Reconceptions of all forms of knowledge have led to significant questions being asked about the power relations inherent

in universal, disembodied vision and the role of new, situated knowledges. Early arguments by such authors as Griselda Pollock and Janet Wolff regarding the implicit masculinity of the *flâneur* (and the impossibility of the *flâneuse*) have been strengthened by more critical post-structural feminist arguments about embodied subjectivity.[17] Post-structural theories of the subject stress the fact that the subject is produced through cultural interaction. There are no pre-existent, objective subjects who enter the world from 'outside' and can, therefore, observe and measure it from a position of complete separation or objectivity. Subjects are always already within the spaces they seek to understand and the traditional paradigms of these disembodied observers who can obtain completely rational truths about the world are misguided. So too, then, is the privilege of the eye/sight as a model for knowing. Not only are other forms of perception equally valid, the objectivity of sight is highly dubious. No eye is without its body, no vision is pure or impartial. These insights underline the critiques of the sciences of space such as geography and physics and change the way one thinks of the interrelationship between bodies and spaces.

Embodied subjectivity and corporeality have been critical components of recent feminist challenges to western notions of space and place. For example, the centre/periphery model itself is challenged by demonstrating that all knowledges are partial and located. The centre is seen to be a myth determined by those in power rather than a universal truth. Furthermore, the margins come into voice through a politics of location. Calling the centre/periphery model into question requires an exploration of borders and boundaries. The boundaries between binary conceptual pairs such as centre and periphery, city and country and, indeed, masculine and feminine or man and woman can only be asserted as fixed and stable in a system which ignores the partiality and specificity of the embodied subject. That is, definite limits and boundaries begin to become mutable and malleable when we reconceive the subject as situated and in process rather than pre-existent and complete. In fact, the very origin of the boundary is derived from the demarcation of the body as an object completely distinct from other objects around it. Thus, questioning space through models of corporeality leads to questioning the body and its boundaries.

Through these insights concerning the particularity of the embodied subject traditional concepts of space can be rethought. As Iris Young has suggested, it is precisely the embodiment of knowledge which counters the old geographical concept of neutral

19

space in favour of specificity of placement.[18] Only in this way it is possible to understand both the gendering of space and the engendering of subjects through space. New models of interactive and mutual/reciprocal relationships between subjects and their situation in spaces can enable revised concepts of women and space to develop outside the traditional masculine models described above.

Elizabeth Grosz has used the feminist concept of corporeality to rethink models of the city specifically in 'Bodies-Cities'.[19] In this essay, Grosz argues that a discontinuous interface between bodies and cities exists and can counter the two most traditional paradigms for understanding the city. The first model, based on the idea that the structure of the city reflects pre-given bodies, reinforces a mind/body dualism and a transcendent, universal body which, as discussed above, is untenable in the light of recent theoretical developments. In the second common model of the city, there is taken to exist a parallel between the body and the urban space (the head represents the head of state and so on). Again, a dualist binary is at play in this, but here it is the culture/nature split instead of the mind/body. Furthermore, such a reading of the city is also inherently masculine while claiming universal status (that is, the model body is male) and assumes that culture is the perfection of nature. In her essay, Grosz moves towards a new understanding of urban space based on neither the subject nor the place being a dominant, pre-existent entity. Rather, she looks towards the notion of the 'user' of the city, the ways in which bodies and cities interact and form one another through discontinuous and flexible encounters.

Such reconceptions of the subject and space are precisely the mechanisms needed to understand the ways in which women artists approach the theme of the city. It is untenable to continue reproducing the traditional modernist versions of city spaces as these have been formulated through masculine paradigms inaccessible to women. Yet, it is still worth exploring the engendering of space and the interaction between bodies, spaces, looking and imaging begun in the modernist project. Thus the women considered in the next chapter of this volume have enacted a renegotiation and sought the ambiguities and ambivalences inherent in modernist practices as a starting point for their work. Like Grosz, they are concerned with the subject and the city, but they find their forms through different models. Grosz's 'user' of the city permits a rethink of the infamous *flâneur*, not simply inverted to the impossible

flâneuse, we move towards what I would call the 'pedestrian' and an aesthetic of pedestrianism.

Introducing a notion such as the pedestrian at this point permits a different model to emerge and, though it is an idea derived from feminist theory and a revision of the masculine modernist figure of the *flâneur*, there is no sense in which the pedestrian is meant to be read as a biological woman; it is about the condition of knowing space through embodiment. In a literal sense, women are more likely to experience the urban environment as pedestrians than are men, but the pedestrian as a concept is more suggestive than this. It is a concept which engages with the modernist paradigm of the *flâneur* and manipulates it rather than simply dispensing with it. This critical engagement with the ambivalence of modernism is a significant feature of the works discussed here. Conceptually, the pedestrian differs from the *flâneur* in her locatedness and physicality. She has a body and a situation in space, but not in the sense of any form of biological essentialism. The 'body' in this context is not a biological given or imperative but the site at which biology and cultural constructions meet and produce a sense of identity or subjectivity. The pedestrian's body and embodiment are themselves a *space* which permits engaged interaction with the world around her. She is not a disembodied eye like the theoretical *flâneur* who wanders through the city 'invisibly' and untouched, but a sentient participant in the city. She realises boundaries as embodied and refutes the *flâneur*'s privileged boundary transcendence and Utopian, unified city.

'Pedestrian' also has the important connotations of the local, the specific, the parochial. It is anything but universal. The pedestrian understands her city through its local communities and the specificity of a politics of location. A concentration on the local and the commonplace is a significant feature of the works in the *City Limits* show. But this sense of the particular and the partiality of the subject's viewpoint is also strategic in its subversion of unified one-point perspective and the totalising gaze of the artist/spectator of the work. In many of the works discussed below, this refusal to permit total visual control and mastery is a critical part of their meaning. It is highly significant that despite working in many different styles women photographers share themes in their city works which engage with this 'pedestrian aesthetic'. Through using direct references to the pedestrian or pedestrian metaphors in their work, they are engaged in the very feminist negotiations of space and knowledge which have formed the theme of this volume.

21

Bodily mediations of the city

One consistent theme in the photographs by women artists which consider the urban is the sense of an interactive encounter between the body and the city. Neither the body nor the city is pre-existent, they are both brought into being and given meaning through their interactive encounters. Identities are mobile, fluid and unfixed in these encounters, constantly being changed by different ways of seeing/moving through the city space. Rosy Martin's work, *Pathways and Traces: Engendering a Sense of the City*, produced particularly for the *City Limits* show, epitomises this approach. Using six paired colour images (reminiscent of the fine art tradition of the diptych), Martin juxtaposes fragments of her own pedestrian's foot on the streets of the city with close-up details of the lines on her skin. As she has suggested in her statement, these works are about 'The body I live in, the city I live in.'[20] In the piece the two are inseparable, each marked by the encounter with the other. For example, in one diptych a blistered toe shows the mark of the city on the pedestrian while the other panel reveals a footprint in the pavement, the trace of the body on the city.

The objects Martin chose to photograph are commonplace yet so taken for granted as to be almost invisible. By shooting images in close-up or with unusual perspectives, Martin defamiliarises ordinary objects, such as the palm of a hand, a nose and the cracks in the pavement, in a way typical of experimental modernist photography of the 1920s and 1930s. Yet Martin's images differ from those of her modernist counterparts in their definitive specificity; modernist macro-images of natural objects such as the famous photographs of Albert Renger-Patzsch from *The World is Beautiful* (*Die Welt ist Schön*) of 1928, were meant to demonstrate the universality of perfect form. Martin shows us the inverse, the particularity of the body and the places it encounters. The very ordinariness of the subjects Martin shows in close-up speaks of the connotation of pedestrian as 'commonplace' or 'parochial', thus subverting the infamous *flâneur* and his Utopian city in a very direct way. Her works also make explicit reference to the actual role of walking in urban women's lives which leads to further questions about the politics of location. Of what significance is the fact of women's walking? There are questions of access, of economic and social power and of threats to women who use the city in this way. But again, the contextual and formal techniques used in these works force the viewer to make more sophisticated connections between the body of

woman and the space of the city than simply acknowledging the ubiquitous woman pedestrian. The juxtaposition of the body with the city in the form of the diptych is deliberate and evocative. Again it defamiliarises and elevates the commonplace. Moreover, these visual conjunctions between bodies and spaces imply their malleability and that they are made what they are precisely through their spatial and metaphorical conjunctions. The city is experienced as a mediated and partial zone, rather than an objective whole. We are made by our locations, given definition through situation.

Emmanuelle Waeckerle continues the dual reference to the pedestrian as literal and figurative in her work, *Roadwork*. This installation piece consists of a video of a pedestrian walking through the city with a long, paper 'road' on his back, the 'road' itself placed in the space, with three slide viewers through which images of the earth, piles of words and a pair of shoes (worn by the video pedestrian) can be seen and a road sign which leads the viewers into the space of the installation. Collectively, it sets up the spaces of the city/gallery as pedestrian; spaces through which people move and encounter objects on foot. Like Martin, Waeckerle stages in her work an interaction between the city and the pedestrian which suggests that neither has pre-existent or pre-determined meaning but, rather, that they are defined through their meeting. Furthermore, *Roadwork* places the nomadism of the subject at its heart and thus develops the idea of fluidity in identity and space. There is no one fixed viewpoint, no single, objective space and no universal, transcendent subject. The pedestrian alters as her location changes and the spectator of the piece is invited to take part in the process through interaction with the work.

Significantly, Waeckerle's work uses text and image together to question language itself as one of the modes through which we define ourselves and the spaces we live in. The 'road' is comprised of text; the 'space' through which we walk to acquire a sense of ourselves is language, social discourse itself. Language, space and subjectivity are all critically interlocked in questions of identity and forced into confrontations/correspondences in this work. The work leaves an opening for the spectator to engage as the pedestrian, rather than as an outside, objective viewer of the filmed pedestrian, and to question her own locatedness. Additionally, *Roadwork* deliberates over the notion of 'home', the very space so distinctly associated with women in our culture. We make our homes through language, we carry them with us and we redefine them whenever we change our situation, literally or figuratively. This embodiment of

23

space challenges any sense of the fixity of the domestic and the fiction of its natural attachment to women.

Esther Sayers's work produced for the *City Limits* show, *Perpetual Transition,* also raised questions about the fluidity of identity and the role of the body as a mediator of urban space. Controlled domestic gardens and grid-like railway stations are superimposed over an image of a fluid and partial body rendering both the city and the subject within it fragmentary and in 'perpetual transition'. Sayers's photographic compositions strike at the ambivalence of the relationship between space and subjectivity as well as its constructed nature providing only provisional spaces and identities. The appropriation of the abstract grid and the visual effects of montage reference the aesthetic experimentation of modernism while the introduction of the partial body subverts its totalising vision. The ambivalence in these works is again reinforced by the bodily encounter of the pedestrian with spaces and their boundaries. There can be no outsider looking in, the *flâneur* does not exist.

While placement and perspective are indicated in Sayers's works as key elements of seeing and rendering space as well as constructing the subject's identity, the doubling of spaces/perspectives reveals these to be transient and partial. Two 'apertures' on the city are constructed in the piece, one through a mirror image and one through dark trees. By multiplying viewpoints and producing a large (17 feet long when mounted), horizontal image, the spectator is denied a fixed perspective or total view of the work. Moreover, the placement of a black mirror in the exhibition space opposite the photograph meant that viewers looking at the image in its reflection encountered their own reflection as well. These features reinforced the impossibility of an objective rendering of any space, all spaces being mediated through the body. Implicit in this approach is the assertion of multiplicity, since many embodied spectators will each have a different but equally valid view of a given space and the objects within it. Furthermore, by interjecting the embodied eye, sight is rendered but one sense amid many and the conception of objective vision and the supremacy of sight as the one sense through which we can finally know the city are lost. Sentient mediation of spaces loosens the hold of the western traditions which made one-point perspective the rule in representations of spatial relationships. As argued earlier, this challenge to seeing and knowing has been crucial to feminist revisions of science and philosophy and is highly significant in women's representational strategies more generally.

24

New modes of seeing/knowing

Both Elizabeth Williams and Alexandra McGlynn have challenged modes of seeing and knowing in their works on the theme of the city, yet, formally, the works are radically different. Unlike the works discussed above, there is no visual representation of the body of the pedestrian, indeed, there are no representations of the body at all in these works. Williams's work, *Inscriptions,* consists of three interspliced text and image pieces (five photographs and four text blocks per piece). The three text/image segments are called 'Desert', 'Borderland' and 'Wasteland' respectively and, though separate pieces, work in tandem by following certain themes and stylistic conventions. McGlynn, by contrast, produced the most aesthetically formal works of the *City Limits* show. *Night Lights* is a series of six prints of individual street lights, at night, lit. They are sparse and extremely seductive in their apparent simplicity.

Williams's work describes three sites on the margins of the city of Oxford which once flourished but have now been abandoned or contaminated. 'Desert' uses photographs taken from the site of an abandoned supermarket, 'Borderland' shows a playground at night and the images in 'Wasteland' are derived from land contaminated by a gasworks. Each piece has one text panel with a dictionary definition of its title which both lends weight to the naming of the sites and questions our reliance on fixed meanings and canonical sources. The other text panels are derived from sources as diverse as literature, history and psychology. The play between text and image is subtle and thought-provoking, rather than definitive or limiting. The final four panels of 'Desert', for example (text panel 3 and 4, photo panels 4 and 5) pair a text from Jewish history with the image of the book on sandy ground and a disused oven in a wall to reference the holocaust. Exploring the dual nature of the word 'desert' as both reward and desolate space (from the dictionary entry) permits a link with Jewish history itself as marked by the contradiction between being both 'chosen' by God and purged by other nations.

'Borderland' continues the sense of duality with images taken from a playground at night and texts from women's diaries and books on female madness. The title is derived from a source about insanity which cited the 'borderland' concept of Darwinian psychology; the borderline between sanity and madness is inhabited by borderland types (women among these) who at any point may swing either way. Hence, the playground, so ordinary and safe in the day, is a

25

borderland at night where it pivots towards danger and discovery. And of course women themselves are situated in a hinterland by their very definition in and through masculine culture as 'other'. Finally 'Wasteland' juxtaposes texts from T. S. Eliot and the Bible with photographs from a 'nature park' which was contaminated by a gasworks. The place could/should be fecund and inviting but is the inverse. The words and images are never just one thing, they are always about an exchange between physical, spatial sites and the social sites we use to describe them.

Significantly, *Inscriptions* is about 'inscribing' meaning. There exists no location and no textual space which is pre-existent or fully imbued with a fixed definition. The social process of inscription which takes place when subjects, spaces and language are brought into contact with one another is fluid and malleable. Macro-histories are brought into being through these micro-encounters of bodies and sites of meaning. *Inscriptions* permits a host of negotiations and reappropriations of central, canonical texts and histories by marginal spaces and social groups. The specificity and commonplace nature of the spaces described in the photographs contrasts with the status usually granted to the canonical texts used in the piece and explores a process through which the marginal may come into voice through the manipulation of the mainstream. In this way, the embodied subject is interpellated by these works; they address the condition of partial vision and locatedness and utterly refute any objective truth claims about the spaces we inhabit. They are about the engendering of meaning and subjectivity. They confound any clarity in the relationship between seeing and knowing and seek to reveal the construction of meaning.

Night Lights is derived from the fascination which greeted the first technical innovations of the late nineteenth century through which it became possible to light, artificially, the streets and shop windows of the modern city. This lighting was part of the formation of the city as spectacle and was also associated with the woman on/of the streets, the prostitute. McGlynn takes this relationship between light, night and the city further than these literal readings and uses these images to question modernism, gender and the metaphorical connotations of 'darkness' and 'light'. The city at night is a borderland experienced by the female subject as both threatening and exciting. The simultaneous pleasure in and fear of the dark is examined by McGlynn through the metaphor of the street light. The style of her photographs which treat these lights as monumental objects is linked to the modernist aesthetics of the so-called 'new

photography'. McGlynn's series negotiates with such representational paradigms of the modern city and moves towards new structures for seeing and knowing the urban which can acknowledge women as producers of space and representation. The works imply an ambivalence at the heart of photography itself by focusing on darkness and the construction of light. They can be seen to challenge the boundaries between light and dark and, in turn, begin the process of deconstructing that crucial binary itself. In this way, these works engage with links between seeing and knowing discussed earlier.

Night Lights considers the disembodiment of vision and objective knowledge without ever representing, literally, the body. Simple and pleasing images are used as complex symbols for sight/knowledge. We are afraid of the dark, of a loss of light, because we are afraid of the loss of sight, of knowledge and of defined subjectivity. As McGlynn wrote in summing up this tradition: 'I see therefore I know.'[21] This is the classic western model of seeing and knowing which privileged the 'objective' sense of sight over all others, the lack of which was the loss of self. But, to enjoy an encounter with darkness, with other sensual perceptions, is to counter this tradition with alternative modes of knowing and is itself a form of subversive discovery. *Night Lights* is about photography in the dark, about the limits of clear sight and the relationship between light and darkness, literally and metaphorically, in our culture and, especially, in our conceptions of space. The city is light at night, it embodies a contradiction in perceptual terms. This cannot be examined through conventional models of seeing with their presupposition of objectivity; rather it posits a new spectator, an embodied pedestrian who is located in the ambivalent space of the city and willing to find new modes of representation appropriate to her placement.

The local, the community

The location of the pedestrian or embodied subject is in local, community space. Women have been linked to community spaces as much as to the domestic sphere through both their actual socio-economic situations and their positioning as marginal others to 'man'. The city centre, with its political and economic power bases, has been the space of men while the peripheral regions of the neighbourhood and the home are tended by women. The very separation of home from work is a fiction of the male subject; women

27

conventionally do not experience such a separation in their ordinary lives as the home is the space of their domestic labour (and often the site of outside labour taken in to be done alongside domestic chores). Hence, women's experiences of the industrial city break down the divisions between public and private spheres and, therefore, between the centre and the margin.

Feminist theories about space which insist upon acknowledging the inadequacies of such models as 'public/private' do so through elaborating the significance of specificity of viewpoint and particularity of location. Magda Segal's documentary photographs of the lives of the Lubavitch Hassids in London is a case in point of the challenges waged by the marginal to the control of the centre. The Hassidic Jewish community is itself one of the marginal communities which thrive on the boundaries of the city. In this way, these works already confront the power relations inherent in centre/periphery models of space. However, the works' internal dynamics are even more pertinent to the issue of the public/private divide and the significance of the body of woman as a demarcation in communities.

Segal showed 17 photographs from her piece entitled *The Lives of the Lubavitch Hassids* for the *City Limits* exhibition. The works were produced as new documentary; they are straightforward black and white photographs taken of the domestic and religious rituals of a particular Hassidic community in London. There is an information panel which specifies this and the titles of the images (such as '15th Child') attempt to give neutral descriptions of the images. However, there is nothing neutral about the spaces which these photographs describe; the Hassidic community strictly separates men and women spatially through various religious and cultural traditions. On important occasions, men and women eat and talk in separate rooms; their activities define and are defined by their location. Segal's photographs show the boys in school with their male teachers or all-male participants in religious activities. Even an image which seems just a neutral domestic interior with women combing their hair in a mirror and talking turns out to be the more formal separation of a 'Young Women's Leadership Course'.

It is in the domestic sphere, however, where the public and the private meet, that the most interesting gender dynamics take place. Young boys take centre stage in a number of the works where Segal has documented the development of male children as members of the community. In the majority of the domestic images, it is the mother at the centre, cooking and caring for children. Male and female children are both part of this maternal sphere when they are

28

young, as the photographs detailing the wedding preparations demonstrate. However, boys will grow into men and leave this space; the mother and her space marks the physical boundary which must be transgressed by male subjects who become the keepers of the traditions. The embodiment and specificity of the female must be transcended in favour of the spiritual, disembodied realm of men. For example, the work which shows 'Opsherin', the ceremony at which three-year-old boys have their hair ritually cut, strand by strand, is a powerful evocation of spatial boundaries. The men of the community enter the home of the boy and cut his hair; the home becomes the site of the public tradition. Hence, 'Opsherin' is an inversion of spatial boundaries with the men usurping the role of the mother in order to place the *male* child into the centre of the masculine, public community. The awkwardness of this gendered spatial transition is again demonstrated by Segal's works. In the work showing a boy's 'Barmitzvah', the public ceremony becomes too much for the child who clings to the comfort of his mother's legs for security; he turns to her body and to the sensation of touch. Finally, the photograph ('Untitled') which shows the boy playing outside while his mother looks out of the window of the house could not render the separate spheres and their gendered definitions more clearly.

Segal's works speak of boundaries and their limits as do the works of Sayers, Martin and Williams discussed above. This is yet another key feature in the work of women artists confronting the theme of the city. Importantly, these boundaries are constructed through the body of the subject who experiences them; they are not conceived as pre-given or natural borders, but structures developed through the interaction of people and space. This again contradicts the typical features of the *flâneur* who could transgress all parameters and achieve total sight. The pedestrian must examine boundaries and negotiate for her partial vision.

Bodily boundaries

Also working in a documentary mode, Debbie Humphry's body of 21 photographs from her on-going project *Gender Crossings*, brought together for the *City Limits* show, might at first seem to have little to do with space. But again, these works consider the spatial concepts of borders, margins and alternative communities through exploring the body itself as a site or space of meaning. Humphry has documented a series of people whose lives and bodies defy

29

conventional gender and sexual borders. The subjects she photographs range from 'Women Taking Testosterone', who pose with their tattooed backs to the camera blurring stereotypes of masculine and feminine, to transsexuals, gay and lesbian couples and even male and female identical twins. All of these people acknowledge a transgression of boundaries in their lifestyle, some even use the spatially loaded terminology 'coming out of the closet'. The photographs themselves place these subjects in opposition to or in connection with borders and their titles invite the spectator to cross boundaries in order to engage fully with the work. The works are divided into sections with textual excerpts between them which attempt to question the viewer's preconceptions about the stability of gender and sexual boundaries.

Significantly, Humphry's work suggests concepts of alternative communities without turning these into marginal spaces in themselves. Rather than pose these figures as 'other' to a unified 'norm', Humphry seeks to interrogate the negotiation with mainstream culture by groups termed 'other' from outside. For example, subjects like the 'Transsexual with Mother and Son' or 'Female Bodybuilder with Daughter' place marginal figures in tandem with traditional family structures. These works are not meant to be about outsiders and freaks from whom we can remain distanced; instead, this body of work queries the whole idea of 'family', 'community', 'sexuality' and 'gender' and renders these terms borderless and decentred. There is a difficult balance to be maintained in this series, however, as the documentary style of the works can sometimes place the spectator (even the photographer) as a sort of anthropologist, examining 'other' cultures. Like much challenging work, Humphry's series treads a fine line between the articulation of different identities and the objectification of these. Reading the texts and seeing the piece as a whole is critical to the project which then begins to imply that the viewer is also part of the process of definition and change. Our bodies too are subject to the social construction of gender and sexuality, we are not fixed observers from outside the work. There are no spatial boundaries without bodies which live in them and the lived activity of bodies can change the boundaries.

Bjanka Kadic focused her *City Limits* work on the theme of the borders imposed upon women and foreigners by the city. *The Position of the Stranger* consisted of seven photomontage works, each of which placed Kadic's body in conjunction with city vistas and a series of 'personal' symbolic objects, such as shells and candles.

Crucially, Kadic's city spaces are ambivalent ones; she reminds us that the margins of cities are often larger than their centres and that immigrant communities flourish in urban spaces which can be more open to disparate forms of community.[22] In this, Kadic is reminiscent of Humphry. So too, in the way in which her works stress the bodily encounter with the spaces and limits of the city for the particular subject. Her subject is neither the universal transcendent 'I' of western, rationalist tradition, nor is it any monolithic concept 'woman'. Kadic's subject is the foreign female, a doubly marginal transgressor of the city. But this transgressor is located both within and without; the city is an ambivalent space to the stranger and to the woman. In the eponymous photograph 'The Position of the Stranger', Kadic's figure is confronted by the city as an external barrier, but in the image 'Disjunction in Time', she is confined/defined by her position behind and within the buildings of the city.

Kadic's use of photomontage in her works is interesting both as a reference to modernist images of the city from the 1920s and as a technique which has a strong political history. Photomontage was seen to be a critical mode through which to deconstruct the seemingly natural images produced and manipulated by the mass media. Like the multiple images of Sayers, Kadic's work insists upon the construction of spaces and subjects through representation. The work uses difference and multiplicity to begin the process of redefining the inherent masculinity of the city. Cities are multivalent spaces; they can be liberating and dangerous, useful and desolate. Kadic's images place the pedestrian's body in direct contact with the buildings and other barriers of the city (including political border controls such as passports and visas). Such a confrontational mode forces an interaction between bodies and cities and the various symbols strewn throughout the works such as shoes, shells and candles give more clues to the nature of this interactive encounter. Shoes signify the nomad, the pedestrian who moves through the city; candles and shells are signs of light and home, those tropes so important to knowing and identity. These too are changed through the bodily use of the city and, as in Waeckerle's work, Kadic's piece suggests that home is fluid and mobile.

Karen Ingham's work *Lost* consists of a body of photographs, eight of which were shown in the *City Limits* show. Seven of these photographs placed a child's toy or article of clothing in a common space such as a park or playground while one showed a child with a toy gun in his mouth. The play between 'still-life' and 'portraiture' in

this juxtaposition is important to the overall reading of the piece which refuses a straightforward interpretation. Stylistically simple, the works are very effective and challenging to the viewer. There is a disconcerting lack of certitude about the subject of these images; of what significance is the placement of these little children's items? Familiar spaces and objects are made unfamiliar and disquieting through their juxtaposition and the works suggest at least one sinister but common phenomenon of the city: the abduction and murder of children. Particularly in the wake of the Jamie Bulger murder in Liverpool, the work which shows a child's harness abandoned on the floor of a shopping mall can imply a very disturbing scenario. These works describe the dangerous borders of the city and the threat of transgression. Such readings destroy any myth of perfect domestic bliss or safety and implies one of the very real physical borders of the city and its spaces for women and children.

However, *Lost* is not just a straightforward lament for lost children. This work marks out far more difficult and problematic terrain. 'Lost' could refer to the children, but equally to lost innocence or the loss of the naive child so desired by the parent. As Ingham herself makes clear, the spaces described in these works have many implications and dangerous places are also places of discovery and knowledge.[23] Hence, children must encounter liminal spaces in order to grow up and their independence is bought at the expense of their total safety. Moreover, children themselves are capable of great cruelty and their own spaces can sometimes seem barbaric and abhorrent to adults. This is why the eighth image of the series (the only portrait of a child) is so critical to the reading of this piece. The child places the toy gun in his mouth. This is not a funny enactment of adult behaviour, but a frightening exercise in children's own fantasy worlds.

Utopia, fantasy and the future

The works described thus far have had a number of interlocking and overlapping themes in common from their reinvestigation of the modernist paradigm, their direct and implied references to the body of the pedestrian, their assertion of the commonplace, the local and the community to their exploration of new models of seeing and knowing. All of these themes re-emerge in the final work considered here, *Tarfeather*, the interactive multi-media piece produced for *City*

Limits by Michelle Henning. This work is computer-generated digital imagery and works, literally, through the participation of the audience who must make the various strands of narrative function as a projection in the gallery space.

This work was conceived as an engagement with modernism's heroic conception of the city and its aesthetic Utopianism. There is a great sense of the pleasure involved in the negotiation with these models and moving beyond them, rather than a simple rejection of their authority. One 'half' of the parallel (but not wholly resolved) narratives of the city produced in the piece is a play on the modernist comic strip city which is traversed by the superhero; it toys with the pleasurable investment we have in such fictive city spaces as 'Gotham City' which can be rendered as pure fantasy, controlled by the viewer. In *Tarfeather* this space is represented by the movement up the factory stairs and out on to the rooftop by the central character of the narrative. In this space, she becomes much more powerful and in control of her environment than she is in the other 'half' of the narrative/visual space in which she is a pedestrian. Once out on the roof, the character's line sums this up: 'I can see the whole city laid out before me.' The ultimate Utopianism of such spaces and their impossibility is interrogated by Henning's work, which comes to the final point of exposing the myth of the superhero, but yet allows the user of the piece to engage with the fiction of the heroic, empowered spectator of the city. This 'play' is the space of fantasy and future possibilities. Like the feminist science fiction of the last two decades, such interventions allow women a space for empowered and alternative forms of fantasy which, arguably, can help to think new identities long before these can be realised in practice.

The spaces of the city in the 'other' side of Henning's split narrative are the spaces of consumption as experienced by the female pedestrian whose body is explicitly referenced in the piece at a number of points. The central character is linked to generations of women in the city through such scenes as the dissolve from the protagonist rolling a cigarette to scenes of women factory workers in the tobacco industry from the turn of the century. The shoes, legs and feet of the character remind us that she walks through this space and her thoughts (which narrate this 'side' of the piece) are also 'pedestrian'. These are the features of the pedestrian seen so frequently in the other works discussed in this volume and the very views which deny any universal conception of the city to remain dominant. Henning stresses the use of the city rather than any

33

voyeuristic access to it as a spectacle. This city is multiple and malleable, like the pedestrians who go through it.

The fact that there are dual and unresolved narrative strands in Henning's work is not accidental; these indicate the displacement of traditional totalising views of the subject and the city. In this work, the body and the city are only partial and incomplete. They shift and change in conjunction with one another and through the manipulation of the user of the piece. Furthermore, it is possible that no two users of the work will engender exactly the same 'story' or interactions. This is also a critical revision of any sense of narrative certainty or authorial control. *Tarfeather* also engages in a reconception of seeing and knowing through the mechanism of 'fictive invisibility' described elsewhere in this volume. As a crucial feature of feminist reconceptions of spaces, the central character voices the disparity between pedestrian experience and Utopian experimentation thus: 'Sometimes people stare at me and sometimes I'm invisible.'

In many ways then, Henning's piece sums up the strands of this volume as a whole. Contemporary women photographers who approach the theme of the city do so through reworking and revisiting powerful modernist representational strategies in the light of new feminist challenges to concepts of space and place. As they stand, the universal and disembodied models derived from modernism are masculine and do not speak of the experience of women in the city. But modernism was complex and contradictory and its aesthetic investigations of the city can be reformulated in the light of this. In order to construct new ways of conceiving the city, however, it is necessary to think through the implications of marginality and embodiment and engage with the space through a politics of location. The 'pedestrian' which comes from these politics of location is both a descendent of the *flâneur* and a subversion of his ostensible gender-free status. The pedestrian's bodily encounters with the city provide the interactive model necessary to permit the engendering of the urban to be envisaged in representation.

Notes

1. E. Grosz, 'Space, Time, and Bodies', in her *Space, Time and Perversion*, pp. 83–102, p. 92.
2. G. Rose, *Feminism and Geography,* p. 140.
3. G. Rose, *Feminism and Geography,* p. 4.

4. V. Woolf, *A Room of One's Own*.

5. S. Ardener, 'Ground Rules and Social Maps for Women: An Introduction', in S. Ardener (ed.), *Women and Space,* pp. 1–30, p. 1.

6. S. Ardener, 'Ground Rules and Social Maps for Women', p. 23.

7. E. H. Gombrich, *The Story of Art*, p. 458.

8. W. Chadwick, *Women, Art and Society*, pp. 214–15.

9. R. Jensen, *Marketing Modernism in Fin-de-siècle Europe*.

10. G. Simmel 'The Metropolis and Mental Life' (1902–3) in C. Harrison and P. Wood (eds), *Art in Theory 1900–1990,* pp. 130–5, p. 131.

11. M. Larionov reprinted in G. H. Hamilton, *Painting and Sculpture in Europe 1880–1940*, p. 309.

12. K. Malevich, 'Non-Objective Art and Suprematism' (1919), in C. Harrison and P. Wood (eds), *Art in Theory 1900–1990*, pp. 290–2, p. 291.

13. P. Jelavich, *Munich and Theatrical Modernism*.

14. D. Rowe, 'Desiring Berlin: Gender and Modernity in Weimar Germany', in M. Meskimmon and S. West (eds), *Visions of the Neue Frau,* pp. 143–64, p. 154.

15. S. Ardener, 'Ground Rules and Social Maps for Women', p. 26.

16. W. Benjamin, 'Central Park' (1927–37).

17. G. Pollock, 'Modernity and the Spaces of Femininity', in her *Vision and Difference*, pp. 50–90; J. Wolff, 'The Invisible Flâneuse: Women and the Literature of Modernity', in her *Feminine Sentences*, pp. 34–50.

18. I. Young cited in S. Ardener, 'Ground Rules and Social Maps for Women', p. 144.

19. E. Grosz, 'Bodies-Cities' in her *Space, Time and Perversion*, pp. 103–10.

20. R. Martin, statement, Chapter 2, p. 44.

21. A. McGlynn, statement, Chapter 2, pp. 46–7.

22. B. Kadic, statement, Chapter 2, pp. 41–3.

23. K. Ingham, statement, Chapter 2, pp. 39–40.

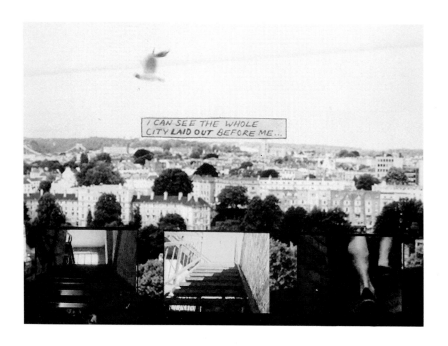

Michelle Henning, stills from *Tarfeather*, 1996

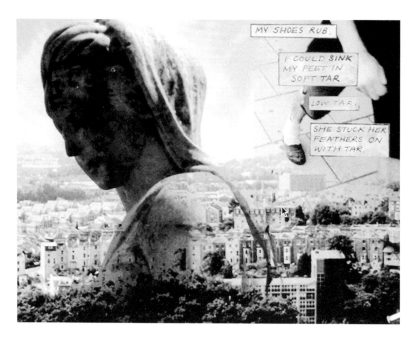

Debbie Humphry, 'Women Taking Testosterone' from *Gender Crossings*, 1995

38

Debbie Humphry, 'Transsexual with Mother and Son', from *Gender Crossings*, 1994

39

Karen Ingham, 'Boy with Toy Gun' from *Lost*, 1996

Bjanka Kadic, 'The Position of the Stranger' from *The Position of the Stranger*, 1966

Bjanka Kadic, 'Disjunction in Time' from *The Position of the Stranger*, 1996

Rosy Martin, *Pathways and Traces: Engendering a Sense of the City, part 2*, 1996

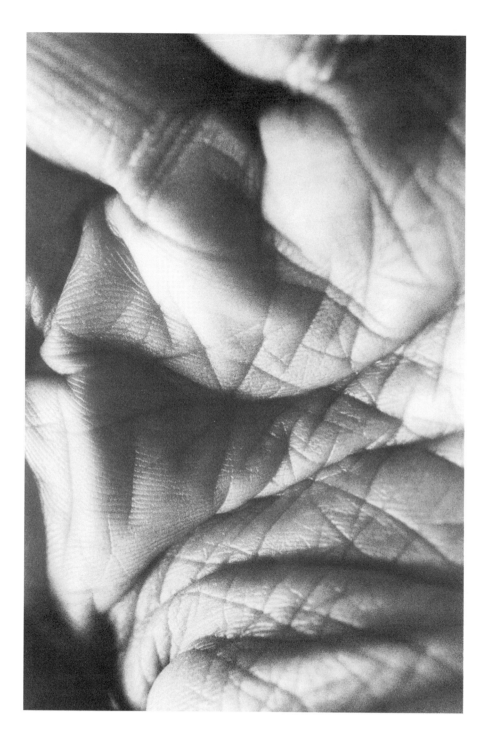

43

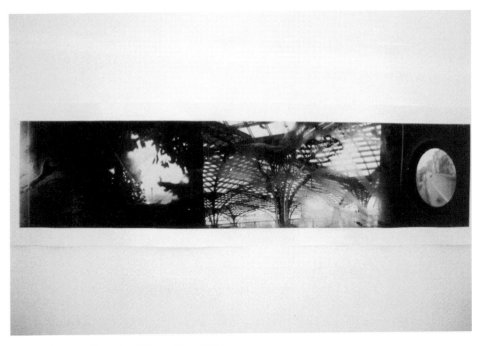

Esther Sayers, *Perpetual Transition*, 1996
Esther Sayers, *Perpetual Transition*, (detail), 1996

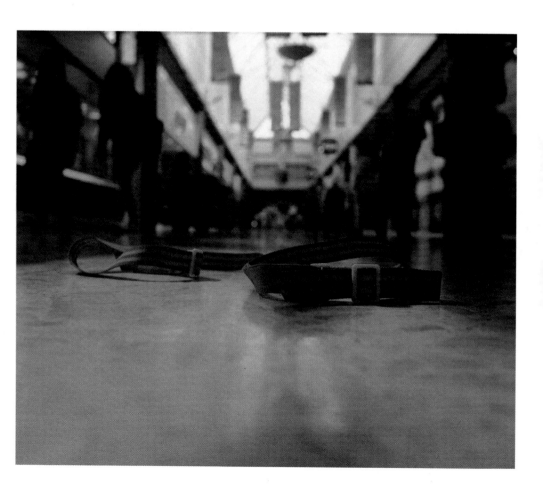

Karen Ingham, 'Child's Reins in Shopping Mall' from *Lost*, 1996

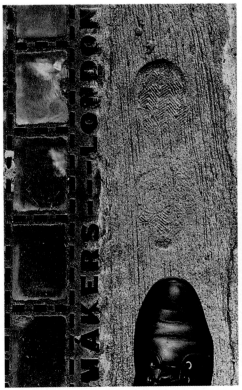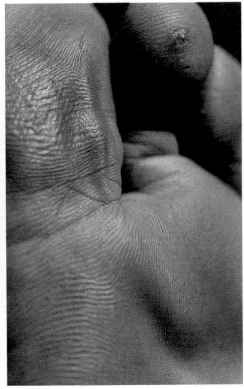

Rosy Martin, *Pathways and Traces: Engendering a Sense of the City, part 5*, 1996

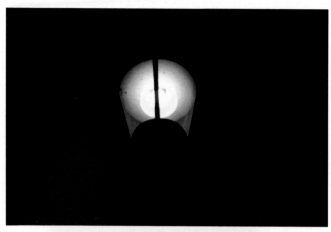

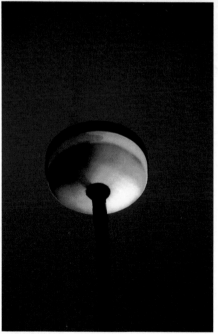

Alexandra McGlynn, 'Mercury Lamp' from *Night Lights*, 1996
Alexandra McGlynn, 'Low Pressure Sodium Lamp' from *Night Lights*, 1996

Between sanity & madness

there is a territory like a darkened moor,

full of peat bogs, & mists,

with no perceptible water-shed or frontier.

The moisture sinks into the ground,

is sucked up, & its division,

whether it flows to Sense or madness,

takes place invisibly & underground.

DANGER
DEEP WATER
NO SWIMMING ALLOWED

borderland *n.*

the district on either side of a border.

an intermediate condition

(e.g. between sleeping and waking).

an area for debate.

And he added:

'If our pages are of incomparable whiteness

it is to dazzle and scare off

all inexperienced readers,

but it is also an eminently charitable gesture

to hide from our impatient eyes, for a moment,

the drop of blood we shed

and whose sudden sight would frighten us.'

borderland/n
the district on either side of a border.
an intermediate condition
(e.g. between sleeping and waking).
an area for debate

Between sanity & madness
there is a territory like a darkened moor,
full of peat-hags, & mists,
with no perceptible water-shed or frontier.
The moisture sinks into the ground,
is sucked up, & its division,
whether it flows to sense or madness,
takes place invisibly & underground.

Elizabeth Williams, 'Borderland' from *Inscriptions*, 1996

'My people of words' said Reb Ezzin,
'how sweet to our eyes, how hostile
to others, so much have you suffered
from their tendentious reading!

'Immense, the book of our deserts,
O word exhumed from red centuries
to red centuries'

And he added:
'If our pages are of incomparable whiteness
it is to dazzle and scare off
all inexperienced readers,
but it is also an eminently charitable gesture
to hide from our impatient eyes, for a moment,
the drop of blood we shed
and whose sudden sight would frighten us.'

Elizabeth Williams, 'Desert' from *Inscriptions*, 1996

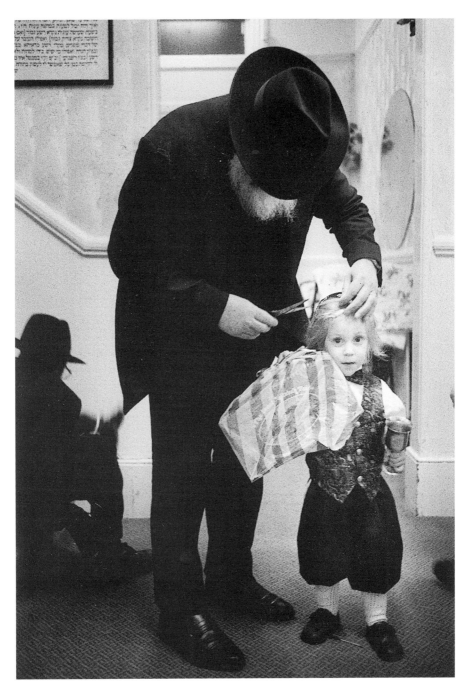

Magda Segal, 'Opsherin' from *The Lives of the Lubavitch Hassids*, 1996

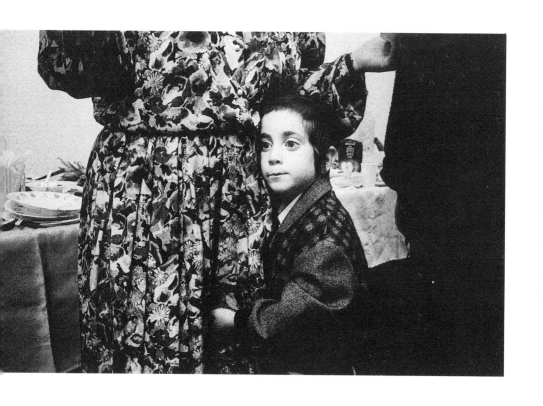

Magda Segal, 'Barmitzvah' from *The Lives of Lubavitch Hassids*, 1996

51

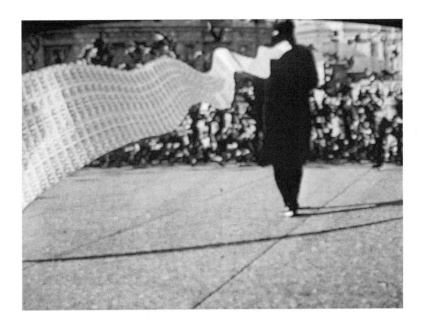

Emmanuelle Waeckerle, *Roadwork* (video still), 1996

Emmanuelle Waeckerle, *Roadwork* (detail, sign), 1996

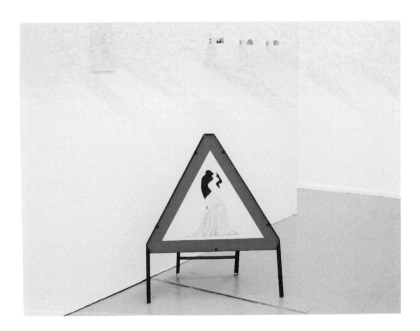

52

2 The Artists: Statements and Biographical Details

Michelle Henning

I work in a wide range of media, mainly montage or collage-based, bringing together imagery and styles to disrupt normal ways of making (narrative) sense through categories and classifications such as masculine/feminine. *Externally Yours* (1993–6) involved using the conservative version of 'femininity' constructed in cosmetic advertising to rework a medium often associated with masculinity (computer games, etc.). *Washing Sequence* (1995) used continually repeated images of a woman washing, accompanied by the repetition of supposedly high-tech terms from skin cream ads ('hyaluronic acid', 'ceramides'). *Flats and Dams* (1995) juxtaposed domestic modernism (British 1960s and 1970s housing projects), the design of which depended on assumptions about women's role in the domestic space, with the more heroic dam-building projects of the Tennessee Valley in the late 1940s.

My work makes critical/affectionate reference to Utopian aspects of modernism and deals with narrative, particularly the relationship between 'grand' narratives and more particular, localised and subjective ('pedestrian') stories. *Stories for the Red at Heart* (1993, reworked 1995) involved three suspended perspex panels based on newspaper photos of three stages of the removal of Soviet statues, photocopies of my own hands, images from style magazines, with a composition derived from El Lissitsky. *Fading Girl* (1992–3) was based on the face of a girl in a Soviet Socialist Realist painting, decontextualised and photographed from the TV screen as the face dissolved away. *Travelogue* (1994) drew on Cendrar's modernist poem about a trans-Siberian train journey, my own journey through France and TV images of the moon landings (which were being shown at the time).

The piece made for the *City Limits* show, *Tarfeather*, is an interactive computer projection which tells a story using animated photographs, drawings, video, sound and text and which draws on the visual and narrative styles of superhero comics as well as descriptive novels and montage film. Based on a contemporary city (Bristol), it juxtaposes the feelings and stories of a woman living in

the city with the planners' or developers' distanced vision. The rapid, disorienting pace of change in the city provides a context for the drifting memories and trains of thought which belong to the (unemployed, single) pedestrian with nowhere particular to go.

Tarfeather (1996)
Music by Veruca Salt, John Parish and Polly Jean Harvey.
Drawings made and animated by Beccy Goddard.
Production Team: Michelle Henning, Tracey Ashill, Helen Clark, Becky Bishop, Gail Kirkbridge, Ben Wallis, Mark Evans, Adam Nieman; with assistance from Becky Wallis, Sam Giles and Vicky Walsh.

Biography

Michelle Henning was born in 1967 and currently works from Bristol. She received her BTEC National Diploma in General Art and Design from Somerset College of Arts and Technology in 1986. In 1989, Henning graduated from Goldsmith's College with a BA Hons in Fine Art and Art History. She completed her MA in Social History of Art at Leeds University in 1990. Henning currently works as a lecturer in cultural and media studies at the University of the West of England, has lectured in fine art and media and design as well as given a number of public lectures and conference papers.

Selected exhibitions

Solo shows
Inflection, Lawrence Hill, Bristol, 1992
Stories for the Red at Heart, Prema Arts Centre, Dursley, Gloucestershire, 1995

Group shows
She Heard it On the Radio..., Watershed Media Centre, Bristol, 1992
Inhetmah, Epstein Building, Bristol, 1992
Telling Tales, Ikon Touring Exhibition, Birmingham, 1994–5
The Whole Shebang, Bristol, 1994
From Silver to Silicon, Watershed Media Centre, Bristol, and touring, 1994 (published on CD Rom by Artec, 1996)
High Tides, Watershed Media Centre, Bristol, 1995
Reflective Mechanisms, F-Stop Gallery, Bath, 1995
Harmless as Butterflies, Bristol, 1996

Selected Publications

'Digital Encounters: Mythical Pasts and Electronic Presence' in M. Lister (ed.), *The Photographic Image in Digital Culture* (London: Routledge, 1995), pp. 217–35.

Debbie Humphry

In *Gender Crossings* I am looking at what gender means, ways in which we are defined by it and how we move from the polarities of masculine and feminine to cross the boundaries. The pictures are of individuals who move towards what is conventionally acknowledged as the opposite gender – in dress, at work, at home, sexually and surgically. This project aims to look at the issue of gender crossing as a whole, from the extreme to the acceptable, at a time in western culture when people are fighting their way 'out of the closet'. Beyond fashionable media representations exists a complex story told by diverse voices.

These are ordinary people moving through the world and I show them in relation to their environment, their friends, colleagues, partners, families and the public. They are also making a world for themselves: creating, settling and changing. I want to challenge prejudice by providing familiar contexts and increasing information. I hope for empathy not voyeurism.

The questioning of gender identity has implications for all men and women. We are swamped by images presenting a stereotypical 'norm' for gender behaviour which is restrictive for everyone. The juxtaposition of text and photographs is intended to raise and answer common questions about the subjects, upturn popular prejudices, place current western notions of gender into a broader context and highlight gender as a social construct, rooted in sexism.

I am photographing people who have the courage to be who they want to be. I hope that some of that positive energy is transmitted in the photographs.

> These are ... people who appear like metaphors somewhere further out than we do, beckoned, not driven, invented by belief, author and hero of a real dream by which our own courage and cunning are tested and tried; so that we may wonder all over again what is veritable and inevitable and possible and what it is to become whoever we may be. (D. Arbus, 'Magazine Work', *Aperture*, 1984, p. 14)

55

Debbie Humphry was born in 1960 in Scarborough and now works as a freelance photographer in London. She received her BA in English Literature from Stirling University in 1982 and began working as a professional photographer in 1986. In addition to producing portraiture and documentary for clients as diverse as the BBC, the Terence Higgins Trust and the *Observer* Magazine, Humphry teaches photography and is currently studying for an MA in Gender and Society at Middlesex University.

Selected exhibitions

Solo shows
Documentary of a School, Tricycle Gallery, London, 1987
Special Needs Facilities in Hackney, Hackney, 1990

Group shows
Kingsgate Annual Show, London, 1992, 1993, 1994, 1995 and 1996
Resourceful Women, Flaxman Gallery, Staffordshire University, 1994
Women Light Up the Night, Kuntshaus Tascheles Hof, Berlin, 1994
John Kobal Portrait Award, National Portrait Gallery, London, and touring, 1994
Home Truths, South Bank Photo Show, London, 1995

Karen Ingham

Lost is a new body of photographic work that explores our fears for our children's safety with particular reference to our present socio-cultural fixation with child murders and abductions. The work is primarily a personal exploration of my own complex and contradictory emotional response to my two-year-old son's growing desire for independence and self-discovery.

Our fears for our children are real and imagined, the imagined fears more disturbing than the real. The loss that we fear is both literal and psychological, a loss of innocence, a knowledge that there is no safe place to play, that children themselves are capable of great cruelty, that the people and places we forbid are the very places to which the child is drawn; it is the danger that both attracts and repels. As in classic fairytale literature, the forbidden is the fruit

of discovery, confrontations that must be faced in order to be resolved. In our disinfected, 'Disneyised' world of stereotyped 'happy families' we have become blind to our children's need for a private 'secret' world of fantasy and discovery. The media are full of horror stories of child murders, incest, sexual and ritualistic abuse, abductions, lost children. The more frightening the real world becomes the more likely we are to turn to inappropriate and suffocating role models for our children.

The places we fear most are no longer the dark woods and the derelict houses but the busy shopping malls and public parks of our towns and cities. Particularly on the margins of our cities, the 'no man's land' of sparse and neglected streets, tatty parks, litter-strewn fields and anonymous out of town shopping zones are we likely to come across the child's shoe lying in the middle of the road, a single glove abandoned in the deep grass, a bright red mac hidden in the long grass, the abandoned doll or toy gun. How did they get there, what stories could they tell, what danger, if any, do they foretell?

The images in *Lost* have an unsettling quality, a sense of unease permeates the frame, yet nothing certain has occurred. The bright primary colours of the familiar childhood objects suggest safety and familiarity but they are somehow out of context, at odds with their surroundings. They take on a kind of iconic significance. But it is the viewer who supplies the scenario, who imagines the out of frame details, the moments before the rattle was dropped, the doll abandoned, the clothing discarded or lost. The stories these pictures tell say more about us, more about our fears for our children, than they do about the actual objects photographed, the lost, abandoned, discarded icons of childhood.

Biography

Karen Ingham was born in Lancashire in 1959 and raised in the United States until the age of 14. In 1980, she received her degree in Creative Photography from Trent Polytechnic, Nottingham, and she currently works from Swansea. Ingham has taught photography, film and video at colleges in Derby, Doncaster, Nottingham and Swansea as well as co-ordinating media training courses especially for women and acting as Equality Officer for East Midlands regional ACTT. Ingham has also received photographic travel bursaries from the Welsh Arts Council to produce work in East Africa and China.

Bjanka Kadic

In my work I use constructed and manipulated imagery which
predominantly relates to women's experiences of society and their
roles within it. A considerable part of my work draws on ideas of
women's shared history which has been obliterated. A reconstruction
of that history, whether imagined or real, through the use of
archaeological remains, matriarchal symbols and feminist readings
of ancient myths, forms one of my ongoing interests.

A recent series of photographs entitled *Naturally Foreign*
examines the issues of 'foreign-ness' and immigration in connection
with what is supposed to be 'natural' and 'normal'. Here I use the
garden as a symbol for 'human-made' nature with references to
Lewis Carroll's 'Alice' who, on her travels through foreign lands,
continually finds that the rules she knows are no longer valid,
natural, logical or acceptable. On the whole, my work is influenced
by my experience of two different cultures, one 'natural' and one
adopted, and contradictions which arise from that position.

Cities as centres of political and economic power can be regarded
as intrinsically male territories. However, it would be too simplistic to
argue that cities are inherently alien or even dangerous for women.
The old dichotomies between culture and nature, city and country,

urban and rural cannot be questioned if we stick to idealising one side and demonising the other. Cities are not homogeneous entities and their margins, real and symbolic, are usually bigger than their centres. Those margins accommodate a vast diversity of communities, cultures and lifestyles. It is not accidental that the predominant majority of immigrants do not settle in the countryside but in cities.

I approached the theme of 'city limits' as a foreigner, as a newcomer. I placed myself in a direct negotiating position with a cityscape represented by high-rise blocks, tube stations, trains, train platforms and graffiti. My attitude towards the city environment is neither celebratory nor condemning. As a woman, I have to negotiate my own position within it by engaging with its threatening aspects rather than retreating into some false shelter. As there is no depth, no distance between myself and the non-inviting city scenes, a certain amount of tension is produced. I wanted, through this rather confrontational relationship, to expose the uneasy rapport that exists between women and the city. Women and foreigners do not just occupy the margins of the city, their interaction with city environments places them simultaneously outside and within the centre. They are the inside outsiders. I want to keep that unresolved tension between exclusion and inclusion open.

The figure in these photographs always occupies the edge, the boundary between the viewer and the scene which unfolds within the frame. The figure functions as an observer on the edge of the frame (society perhaps) allowing the viewer to observe the observer and the scene or to identify with the figure. I use shoes with candles which walk from and towards the viewer as symbols for wandering, testing the boundaries and exploring new territories, all activities to which inside outsiders are drawn. They can perhaps hint at the search for one's ever evasive sense of community and identity. Shells are used as positive symbols of protection and endurance, of carrying home with us wherever we go. They also symbolise for me adaptability, an ability to create a 'home' wherever we arrive.

Biography

Bjanka Kadic was born in Vinkovci, Croatia, in 1958 and now works in Surrey. In 1982, she completed her BA in Philosophy and History of Art at the University of Zagreb, and in 1995 she received her BA Hons in Photography from the University of Westminster. Kadic has taught in secondary schools in Croatia and has worked as a

59

photographer, graphic designer and exhibitions organiser in the
Acton Community Arts Workshop. She currently works as a
freelance photographer and teaches photography in adult education.

Selected exhibitions

Solo shows
Engaging Women, Merton Civic Centre, Surrey, 1993
Women Jazz Musicians, Chats Palace Arts Centre, Hackney, 1994
Some Fragments, NONA Gallery, Zagreb, 1995
A Sense of Time, Shenfield Library, Essex, 1996

Group shows
The Woman in My Life, Small Mansion Arts Centre, London, and
 touring, 1990–1
Stones in Her Pockets, Midland Arts Centre, Birmingham, and
 touring, 1994
Truth and Illusion, Open Window Gallery, London Buses nos 73 and
 38, 1995
New Art, New Season, Washington Hotel, London, 1996

Selected Publications

'The Woman in My Life: Photography of Women', selected by Mica
 Nava, *Feminist Review* 36, Autumn 1990, pp. 42–51.
'Nona', *Artists Newsletter*, August 1994, pp. 26–7.
'Novel venue', *Artists Newsletter*, April 1996, p. 14.

Rosy Martin

In pondering the particular, I am taking an intimate and challenging
view of the city and the body I have spent my whole life in. My
position is that of a pedestrian's-eye-view of the inner city, a close
and commonplace gaze at the streets which I regularly use in my
daily life, and concentrating on details, surfaces, markings, signs and
messages. These are the ordinary, everyday things that come within
our frame of reference, so ordinary that they go unnoticed. By using
close-up and cropping, these familiar, taken-for-granted passing
glimpses are made strange. The layering of surfaces, the fields that
lie sleeping underneath the flagstones speak of the history of place.
This is not the city of panoramas, grand sweeps and gestures,

edifices that steal the sky, but the city that contains and impinges upon me, a texture of place and memory, of knowing and living.

Turning the macro-lens upon my own body, a mapping of traces of ageing and lines again fragment the familiar. The body as a landscape, a complex structure, boundaried by skin. The city as experienced through the body, through the senses, how it welcomes, excludes, contains and surveys is explored in the photographs.

By mapping the wear and tear of time upon the fabric of the streets and of my own body, like a palimpsest, I explore and isolate tiny details and fragments, pushing at the edge of legibility. This allows the audience to project their own meanings upon the images, which symbolise and stand for the continuity and discontinuity of change over time.

The photographs are presented in pairs, creating a dialogue of linkages and connections between the city details juxtaposed against the body details. The diptychs share a formal relationship, a subtle mirroring or correspondence is hinted at, while both are made strange in the pairing.

My practice is concerned with expanding the notions of self-portraiture through embodying a multiplicity of selves. I have explored the body as a surface for the social and cultural inscriptions of meaning through clothes, gesture and props. In this, my fiftieth year, issues of ageing are coming to the fore, and by re-examining my body as a surface, I am facing its fragility, etched by time.

The body I live in, the city I live in.

Context

Surveys on Women and Transport (in London) show 'the most common way for women to get around London is on foot. Almost 90% of women walk all the way to where they are going at least once a week and nearly 60% walk at least five days a week'. (GLC Women's Committee 'Women and Transport Survey', 1985)

Biography

Rosy Martin was born in 1946 in London, received her BSc in Chemistry from University College, London, in 1967 and continued research in Biological Chemistry there until 1968. From 1968 to 1971, Martin trained as a designer, receiving a Postgraduate Diploma in Industrial Design from the Central School of Art and Design (now the London Institute). She has postgraduate diplomas in specialist design for the disabled and therapy and counselling.

61

Beginning in 1983, in collaboration with the late Jo Spence, Martin pioneered the practice of 'phototherapy' and has since developed these concepts of photographic work to include a number of challenging forms of artistic intervention into the construction of identity and the 'self'. Martin's work crosses boundaries between theory and practice to consider the political and psychic implications of representation.

Selected exhibitions

**Double Exposure – The Minefield of Memory*, Photographers Gallery, London, 1987
* *Transforming the Suit – What Do Lesbians Look Like?* in *Body Politic*, Photographers Gallery, London, 1987
**Notes from Our Psychic Family Albums* in *Matter of Facts*, Musée des Beaux-Arts, Nantes, 1988–9
* *Dirty Linen*, Foto Biennale Enschede, 1989
The Generations of Meaning in *A Daughter's View*, Watershed Media Centre, Bristol, 1991
I Pose a Paradox: A Discourse on Smoking, Rochdale Art Gallery, 1991
New Mournings and *Lighten Up*, Morley Gallery, London, 1994
Transforming the Suit and *Fabrications* in *The Sexual Perspective*, Jill George Gallery, London, 1994
netyourother by Rosy Martin and Nicky West @ http://www.artec.org.uk/channel/sexnet 1995
Out-Takes and * *The Minefield of Memory*, Floating Gallery, Winnipeg, 1996

Selected publications

* 'New Portraits for Old: The Use of the Camera in Therapy', *Feminist Review* 19, March 1985, pp. 66–92; and anthologised in R. Betterton (ed.), *Looking On: Images of Femininity in the Visual Arts and Media* (London: Pandora, 1987).
* 'Phototherapy: Psychic Realism as a Healing Art?', *Ten.8* 1, 30 1988, pp. 2–17.
'Dirty Linen', *Ten.8* 2, 1, 1991, pp. 34–49.
'Don't Say Cheese, Say Lesbian', in J. Fraser et al. (eds), *Stolen Glances: Lesbians Take Photographs* (London: Pandora, 1991), pp. 94–105.

'Unwind the Ties that Bind' in J. Spence et al. (eds), *Family Snaps: The Meanings of Domestic Photography* (London: Virago, 1991), pp. 209–21.

'I Pose a Paradox', *Women's Art Magazine*, 45, March/April 1992, pp. 16–17.

'Home Truths? Phototherapy, Memory and Identity' *Artpaper*, St. Paul, MN, March 1993, pp. 7–9

'Putting Us All in the Picture: The Work of Jo Spence', *Camera Austria* 43–44, Summer 1993, pp. 42–58.

'Memento Mori Manifest' in J. Spence and Joan Solomon (eds), *What Can a Woman Do With a Camera* (London: Scarlet Press, 1995), pp. 67–74.

'You (Never) Can Tell', *Backflash,* Autumn 1996.

* Rosy Martin and Jo Spence

Alexandra McGlynn

The dark is simply a deprivation of light and, in turn, sight. A fear of the dark is a fear of the unknown and a loss of certainty. I see therefore I know. To be deprived of sight is to rely on touch and smell, which may be deceptive. The night may also be a place of discovery – the cover of darkness making anything possible. In photographing at night, either outside or inside in darkened rooms, the darkened space in which I am working requires an adjustment of seeing (and sleeping). Photography is the result of the restless unconscious. Light in places where there is very little takes time to enter the eyes and form an image.

The nineteenth century saw many inventions and discoveries and a rapid development of the sciences and capitalist industry. The inevitable 'fetishism' of commodities was aided by the invention and subsequent massive expansion of photography and electric lighting. Goods for sale could be clearly presented in shop windows previously unseen at night but now lit up with the help of Edison's invention: the filament bulb. And so the department store was born; red neon lighting was also incorporated into signage. The early carbon filament lamps were replaced with the four-sided glass-boxed mercury lamps and these in turn gave way to the yellow and pink sodium lamps still in use today. Representations of women, through paintings and photography, continued and consolidated the stereotypes of the prostitute (seller and commodity), the dancer or actress (the spectacular and exciting commodity) and the beautiful,

63

wealthy woman, endlessly beguiling. The 'home' of the prostitute was the street. Her trade was restricted to certain areas of the city which benefited first from gas street lighting and later electric lighting. Thus the marginalised and shadowy figure of the prostitute suddenly became, literally, visible for the first time. One of the oldest professions was reborn, appropriately enough, with nineteenth-century Victorian technology.

Biography

Alexandra McGlynn was born in 1958 and currently lives in London. She received her BA in Fine Art from Newcastle-upon-Tyne Polytechnic in 1981 followed by a Diploma in Social Anthropology from Birkbeck College, University of London, in 1989 and an MA in Photographic Studies from the University of Derby in 1991. McGlynn works as a lecturer in photography at the Liverpool John Moores University and has works in public collections in London, Washington and Lisbon. Her shows have been reviewed in such places as *Creative Camera*, the *Guardian*, the *Independent* and *Time Out*.

Selected exhibitions

Glass Piece, Brewery Arts Centre, Kendal, 1992
Woman with Claws, sound installation, Liverpool, 1992
Domestic Parameters, F-Stop Gallery, Bath, 1993
Hotel des Voyageurs, Hotel d'Angleterre, Lamballe, Brittany, 1993
Somewhere in Particular, Bluecoat Gallery, Liverpool, 1994
Women Light Up the Night, Kunsthaus Tascheles Hof, Berlin, 1994
Surplus Enjoyment, sound installation as part of *Works Perfectly*,
 curated by Rear Window, London, 1994
The City of Dreadful Nights, curated by Rear Window, Atlantis,
 London, 1994
Hearing is Believing part of *Video Positive*, Movieola, Liverpool, 1995
Good Dog, Bad Dog, sound installation for *Pet Politics*, Plunge Arts
 Club, London, 1996

Esther Sayers

My recent works have used self-portraiture to examine the simultaneity of the body's role as both subject and object. They have looked at the fractured and partial nature of the subject's access to

64

an image of herself in which the whole, external view is denied. In these images I have chosen to represent the body without a clear, defining edge, explicitly evoking a sense of continual flux. Not being 'fixed' provides the 'self' with endless possibilities for change and transformation in the construction of identity. I have represented the body as a garment which is constructed and worn consciously by the subject; it provides protection, a barrier or boundary between the subject and the world.

The spectator defines the subject as one object among other objects in the environment. My current works attempt to examine the ways in which subjects define themselves in that environment. One does not 'see' oneself in the world, one 'experiences' oneself in the world through sensation. By visually mapping the surrounding terrain one locates oneself in it.

The notion of a 'frontier' is an important element in this work; 'I' am situated on the border of the world 'I' see. Looking at the world through an aperture or being out in the early morning allows me to see without being seen, to avoid the representation of myself by an Other, to exist without shape or form. Fluidity, as a visual device, is used here to suggest the transgression of boundaries, a sense of self existing freely. However, never-ending space is unsettling. The domestic space of the garden creates familiar territory. The garden could be an extension of our 'natural' bodies, it too is inspected and manipulated according to one's personal aspirations. This examination and construction creates a Utopia, an ideal space beyond the present. Like the garment as a metaphor for the body, the garden also provides a barrier between the subject and the world.

Fences are metaphors for enclosure, they describe both confinement and security. Some act as complete barricades while others provide apertures which allow me to see out and others to see in. Both of these views are mediated by the formal, grid-like structure. While we are often unaware of this ordering, at other times we can become acutely conscious of the boundaries and territories created through such formal means. Physical boundaries are 'actual', psychological boundaries exist in the unconscious and determine one's perception. The specificity of vision means that visual perception is fragmented, the eye focuses only on one small point at a time. This segmentation of vision creates perceptual barriers which cannot be seen easily and are, therefore, difficult to cross or erase. Vision transgresses physical boundaries; I can see into inaccessible places. These spaces are marked as 'private' with physical boundary lines: frosted glass, net curtains, fences others

65

operate as 'territory' with invisible boundary lines which effectively demarcate space.

The subject's position in the world is determined by her physical location in it, for the individual, the boundaries between 'self' and environment are blurred and indistinct. The body is a vantage point, the origin of co-ordinates from which a point of view is established. This work attempts to disrupt the demarcation line which defines body as an object, as passive, to problematise the notion of one fixed point of view and instead to explore a sense of 'self' as active, occupying a plurality of positions.

Biography

Esther Sayers was born in Leeds in 1970 and currently works from Stoke-on-Trent. Having done a foundation year at Middlesex Polytechnic (1988–9) Sayers graduated from Brighton University with a BA Hons in Wood, Metal, Ceramics and Plastics in 1993. In 1995, she received her MA in Fine Art from Staffordshire University. Sayers has worked as a printmaking teacher and currently lectures in photography for the Fine Art Department at Staffordshire University.

Selected exhibitions

Solo shows
Uncertain Terrain, Music Hall, Shrewsbury, 1996
Identi-kit, Watershed Media Centre, Bristol, 1996

Group shows
A Question of Identity, Keele University, 1995
Identity, Manhattan Graphics Center, New York, 1995
Women, Time and Space, Lancaster University, 1995
Inside/Outside, Konstforum, Norrköping, Sweden, 1995
The Shadow of the Object, Ikon Touring Exhibition, 1996
Warming Up!, Nuremberg, Germany, 1996

Selected Publications

M. Meskimmon, *The Art of Reflection: Women Artists' Self-portraiture in the Twentieth Century* (London and New York: Scarlet Press and Columbia University Press, 1996).

Magda Segal

In Stamford Hill, London N16, there is a community of Hassidic Jews. This already narrow community is further broken down into smaller specific groupings. My aim in this series of photographs has been to document the lives of the Lubavitch Hassids – a fascinating and closed community of approximately 220 families. Within this community, television, radio and newspapers are forbidden and important celebrations and festivals reinforce the traditions which hold the Lubavitch together and give them individuality and strength. The Lubavitch Hassidic movement started in 1770 and survives almost unchanged in small communities around the world. Even in central London the life of the community is virtually untouched by everything that surrounds it; it has its own schools, shops and even swimming pool. Against this background, the community preserves a deeply religious, family-centred way of life which more reflects its eighteenth-century origins than a twentieth-century urban environment.

Over the past two years I have come to know members of the Lubavitch community and am greatly privileged to have been given permission to photograph them not only at public festivals but also in the very personal home environment. Each event in the religious calendar has its own, often visual, symbol. *Purim* sees the children dressed up in the streets, carrying food parcels to neighbours and rattling tins to collect money for community charities. The family is a rich source of ceremony. In the first haircutting ceremony (*opsherin*) boys have their hair cut on their third birthday, strand by strand, by the men of the community who come with their families to the home of the child. On this as on all other occasions, even weddings, the men and women eat and talk in separate rooms.

The impetus for producing the work on the Lubavitch Hassidic community came from my earlier portrait and documentary work. Commercially, I have worked for various magazines photographing, for example, Beryl Bainbridge, Alan Ayckbourn, Alan Bennett, Joanna Lumley and Jane Laportaire. My documentary projects include studies of the FANYS (female auxiliary nursing yeomanry), the Scots in Corby, Jewish people caring for their community in Manchester, bikers in Epping Forest, people living and working on the narrow boats in London and Red Indians in Britain. The Lubavitch Hassidic project was one well-suited to adaptation for the *City Limits* show as it documents a closed community living within a

67

city, untouched by its secular surroundings, retaining its own structures, rules and rituals.

Biography

Magda Segal was born in London in 1959 and trained in fashion and advertising photography through her assistantship to Duffy from the age of 16. She has worked professionally for a variety of magazines including *Elle*, *Harper's & Queen* and *Time Out*. Segal works mainly in portraiture and documentary and has work in a number of major collections including the National Portrait Gallery.

Selected exhibitions

Solo shows
London at Home, Museum of London, 1994
Taking Care of Ourselves, Manchester Jewish Museum, 1996
Group shows
Kindness, Hamiltons, London, 1988
John Kobal Portrait Award, Zelda Cheatle Gallery, 1993
John Kobal Portrait Award, National Portrait Gallery, London, and touring, 1994
Photographers' London 1839–1994, History of Moscow Museum, Russia, 1995

Selected publications

London at Home (Manchester: Cornerhouse, 1994).
M. Seaborne, (ed.), *Photographer's London* (London: Museum of London, 1995).
A. Bennett, *Writing Home* (London: Faber and Faber, 1994).

Emmanuelle Waeckerle

The *Roadwork* installation in the *City Limits* show is an extension/conclusion of a piece made in 1995 entitled *Really This is not a Virtual Road* where the road object acts as a visual chant; the repetition of the phrase 'Carry me along, Oh Road' allows the viewer, while reading, to make his/her own connections and associations, to play with the variety of meanings hidden behind a word, a phrase or an image.

In *Roadwork* the carrying of the road object can be seen as a metaphor for the passing of a life, endlessly carrying one's load. It also relates to my idea of 'home' as being a transient space which dwells within us. This may be a reflection of my mixed cultural identity – from Morocco to France to England – where I cannot refer to home as being a particular place. I can only refer to experiences/memories from different places, using different languages that rarely translate well from one another. To speak of 'home' is already to acknowledge language as a construction; hence the use and exploration of words and their meanings in almost all my work.

As urban dwellers we cannot inhabit every inch of a city, we can only exist in a limited territory open to chance, choice or, more often, obligation. Our territory is limited by notions of cultural origin, gender, social class, political and economic concerns which are in turn orchestrated and homogenised by city planners. *Roadwork* is an attempt to disregard and disrupt these limits by going on a subjective 'derive' through the streets of London. It is a conceptual gesture/performance freely witnessed by passers-by. By chancing upon the road object being carried (like the cross to Calvary), they may reflect upon their own movement in life and their own movement through the city, from station to station.

Biography

Emmanuelle Waeckerle was born in 1962 in Rabat, Morocco, and now works from London. In 1991, she received her Diploma in Fine Art and Photography from the City of London Polytechnic, followed by a Certificate in Education from the University of Greenwich in 1993 and an MA in Fine Art/Media from the Slade School of Art in 1996. Waeckerle has taught photography at Lambeth College and the London Guildhall University as well as organising multi-media events such as *Nux Vomica* in 1995.

Selected exhibitions

The London Show, Galleria, Milan, 1992
Resourceful Women, Flaxman Gallery, Stoke-on-Trent, 1994
Chimera, Focal Point Gallery, Southend-on-Sea, 1994
Women in the Streets, billboards, part of *Signals*, London, 1994
Memory, Riverside Studios, London, 1995
Reflections of Technology, Paddington Station, London, 1995
Chimera, Maclaurin Art Gallery, Ayr, 1995

69

Carry Me Along, Oh Road, Arts Projects International, New York, 1995

The Missing Link, Syndicated Art, London, 1995

Small Works, Arts Projects International, 1995–6

Elizabeth Williams

Inscriptions proposes that we cannot approach spaces as neutral but inscribe them with meaning formed from an archive of public and private reference. I have inscribed three sites on the margins of the city of Oxford with images and texts that classify them as 'Desert', 'Borderland' and 'Wasteland'.

The transition from the limits of the city to those of the rural is often a gradual passage through an increasingly marginal and forgotten space. Belonging to neither identity, these spaces both confront and offer refuge from the stereotypical and mainstream.

The western tradition of landscape in visual representation has been dominated by the map in topographical work and the inspiration of the romantic sublime in art practice. The former implies control through classification, and the latter, an essence beyond the site itself. *Inscriptions* engenders meaning which is not fixed or essential, but a relative and complex reading which contributes to an ever-changing and fluid debate.

Three interlocking themes thread throughout the work: that of 'no man's land', a space unclaimed by mainstream society; that of a moral or ethical judgement and retribution; and, finally, that of water as a supportive element both literally and metaphorically.

The relationship of image and text is in constant flux, one defining and redefining the other and suggesting that within the archive there is 'unspeakable' meaning. As A. P. Hinchcliffe wrote about T. S. Eliot's poem *The Waste Land*: 'This is not a poem of ideas with an argument but rather a poem of emotions about a land that had once been fruitful but no longer is, about life that once had meaning but no longer has' (A. P. Hinchcliffe, 'Storm Over the Waste Land', in *The Waste Land and Ash Wednesday*, 1987.)

Biography

Elizabeth Williams was born in London in 1949 and now works from Oxford. Williams completed her Foundation Course in 1967 at Winchester School of Art, gained her BA in Fine Art at the University

of Central England in 1971 and received a Higher Diploma in Creative Photography from the London Institute in 1975. She also holds a Postgraduate Certificate in Education from the University of Reading for whom she has worked as a visiting lecturer since 1994. Williams has lectured widely on photography as well as holding numerous residencies throughout Britain, Europe and in Egypt.

Selected exhibitions

Solo shows
Seven Miles of Mind, Montage Gallery, Derby, 1994
Strange Territory, Museum of Modern Art and Pitt Rivers Museum, Oxford, 1994–5
Seven Miles of Mind, Watershed Media Centre, Bristol, 1995
Seven Miles of Mind, Museum of Photography, Antwerp, Belgium, 1996

Group shows
Towards a Bigger Picture, Victoria and Albert Museum, London, and touring, 1987–9
Through the Looking Glass: British Photography since 1945, Barbican Art Gallery, London, and touring, 1989
Nature after Nature, John Hansard Gallery, Southampton, 1990
Viewfindings, Newlyn Art Gallery, Cornwall, and touring, 1994–5
Warworks, Nederlands Foto Instituut, Rotterdam, and touring, 1994–6
The Dead, National Museum of Photography, Film and Television, Bradford, 1995–6

Selected publications

J. Stathatos, Multiple Originals (London: Photographers' Gallery, 1987).
G. Badger, Through the Looking Glass (London: Barbican Art Gallery, 1989).
W. Beckett, Art and the Sacred (London: Rider Books, 1992).
L. Wells, Viewfindings – Women Photographers, Landscape and Environment (West Country Books, 1994).
V. Williams, Warworks: Women, Photography and the Iconography of War (London: Virago, 1994).
V. Williams, and G. Hobson, The Dead (Bradford: Museum of Photography, Film and Television, 1995).

Selected Bibliography

Ardener, S. (ed.), *Women and Space: Ground Rules and Social Maps* (Oxford: Berg Publishers, 1993).

Benjamin, W. 'Central Park' (1927–37) trans. L. Spencer with M. Harrington, *New German Critique* 34, Winter 1985, pp. 32–58.

Braidotti, R. *Nomadic Subjects: Embodiment and Sexual Difference in Contemporary Feminist Theory* (New York: Columbia University Press, 1994).

Chadwick, W. *Women, Art and Society* (London: Thames and Hudson, 1990).

Gombrich, E. H. *The Story of Art* (London: Phaidon, 14th edn 1984).

Grosz, E. *Space, Time and Perversion* (London: Routledge, 1995).

Hamilton, G. H. *Painting and Sculpture in Europe 1880–1940* (Harmondsworth: Penguin Books, 1984).

Haraway, D. *Simians, Cyborgs and Women: The Reinvention of Nature* (London: Free Association Books, 1991).

Harrison, C. and Wood, P. (eds), *Art in Theory 1900–1990: An Anthology of Changing Ideas* (Oxford: Basil Blackwell, 1992).

Horner, A. and S. Zlosnik, *Landscapes of Desire: Metaphors in Modern Women's Fiction* (Hemel Hempstead: Harvester Wheatsheaf, 1990).

Jelavich, P. *Munich and Theatrical Modernism: Politics, Playwriting and Performance* (Cambridge, MA: Harvard University Press, 1985).

Jensen, R. *Marketing Modernism in Fin-de-siècle Europe* (Princeton, NJ: Princeton University Press, 1994).

Meskimmon, M. and West, S. (eds), *Visions of the Neue Frau: Women and the Visual Arts in Weimar Germany* (London: Scolar Press, 1995).

Pollock, G. *Vision and Difference: Femininity, Feminism and the Histories of Art* (London: Routledge, 1988).

Rose, G. *Feminism and Geography: The Limits of Geographical Knowledge* (Cambridge: Polity Press, 1993).

Wolff, J. *Feminine Sentences: Essays on Women and Culture* (Cambridge: Cambridge University Press, 1990).

Woolf, V. *A Room of One's Own* (1929), ed. and introduced M. Barrett (Harmondsworth: Penguin, 1993).